DUBLIN

Donated to

**Visual Art Degree
Sherkin Island**

AN ARRANGEMENT OF PICTURES

Photographs © 2000 Louise Lawler
© 2000 Assouline

Assouline Publishing
601 West 26th Street
18th floor
New York, NY 10001
USA

www.assouline.com

ISBN: 2 84323 211 2

Printed in Italy

LOUISE LAWLER

AN ARRANGEMENT OF PICTURES

ASSOULINE

Corner, 1980

black and white photograph
4$^{1/2}$ x 7"

THE SITES OF ART
PHOTOGRAPHING THE IN-BETWEEN

The idea that works of art have a stable, aesthetic meaning, independent of their location and surroundings, was blindly accepted for hundreds of years in the modern era. Next to a work of art's autonomous aesthetic meaning, its location was a matter of chance alone and without significance: it remained the same work wherever it was. It was only after the collapse of idealistic modernity around 1960 that the work of Daniel Buren and Marcel Broodthaers—following through on the ideas pioneered by Marcel Duchamp between 1913 and 1921—directed people's attention to the previously unacknowledged fact that works of art always occupy a space, that they are always in a particular location and situation. The conclusion these artists came to was that the literal and institutional space that surrounds a work of art determines its perception and evaluation to a high degree. The very fact that an object can be recognized as a work of art presumes either from its appearance or its location that the object is a piece of art. The hints conveyed by surroundings of this kind rely on a broad cultural awareness that individuals learn subconsciously. This cultural awareness encompasses the ability to distinguish between different types of objects, interpret "attitudes," choose ways of looking, and decide how one is supposed to behave, all of which allow the individual—prior to any aesthetic or artistic assessment—to decide whether to treat an object as a work of art or as something else—a functional or decorative object, perhaps.

The perception of an object as a work of art is determined above all by two very different institutions that both pass judgement on whether an object should or should not be considered art (the rejects being hailed with "That's not art!") and establish the criteria as to how it should be judged once it has passed the test. The first institution, "academe" (art history, art theory, museums, catalogues, and certain art critics), conducts aesthetic and historical debates on works of art and judges them. The second institution, "the market" (galleries, collectors, investors, auctioneers, banks and magazines: a very different group of art critics), treats works of art as rare goods whose circulation and distribution conform to the rules of commerce. Art functions by virtue of its fictive value in both types of institutions: it is fictive in commercial terms in that its value is purely speculative, and it is fictive in academic terms in that it has no calculable significance other than as substantiating evidence in historical or aesthetic debate.

Works of art can function in both institutions simultaneously due to the diffuse mixture of criteria by which they are judged—criteria that mingle economics, semantics and libido. They are desirable because they are rare, valuable and culturally charged, and because they have a certain meaning—or are even meaningful. They acquire these qualities through the originality and authenticity of their maker, the artist. Their social significance, cultural status and even their character as special, auratic objects are endowed upon them above all by the institution "academe" (which, again, includes museums and art-historical institutes), although it is their market value that creates a firm foundation for the academic evaluation. Historical and aesthetic significance and market value have from the point of view of academe nothing to do with each other, and yet they are in reality closely, mutually dependent. And specifically because works of art are both

valuable and meaningful, they are eminently well-suited to set their owners apart, imbuing them with an aura of social distinction.

Louise Lawler's photographs show locations where art is found. She shows what is perfectly visible but rarely seen: the way that works of art are presented in different situations are neither random nor arbitrary: it denotes the "value" of works of art in that the institutions install them as signs of their own value. In this context, works of art become simple, easily recognizable signs denoting a particular value. This form of identification is made possible by a whole series of rules: firstly, the work of art is subordinated to its authorship, which is proved by the signature (name, date and title); secondly, the work of art is marked out both spatially and optically by its frame, its visible isolation in a particular situation; and thirdly, its mode of presentation or exhibition is distinctly institutional.

Louise Lawler photographs works of art in their own contexts, in the most diverse stages of their transportation, presentation and storage: in museum depositories, stores, gallery print-cupboards, private collections, offices, at auctions and undergoing transportation. She shows how they are hung and set up, not only in museums, exhibition spaces and galleries, but also in the homes of collectors and investors. In doing so, on one level her work is strictly documentary: she shows situations—including spatial arrangements and configurations—as she finds them. Her photographs are neutral: they neither denounce nor criticize, nor do they take a stand with regard to the situation. Louise Lawler does not seek out interesting situations, but she does illuminate constellations. Her method is not a sociological record: she simply finds those constellations and locations in which a situation starts to talk, to reveal its hidden implications. Her photographs are not about evaluation and analysis, but about allowing the mental and social reality behind the visible surface of the situations to reveal itself. She refrains from interpreting situations in any way; she lets her discoveries—these *situations trouvées*—retain their open-ended ambiguity. And it is precisely this neutrality, this laconic lack of commentary, that opens the situations up for a deeper view—one that is neither purely sociological nor purely aesthetic.

The most important aspect of Louise Lawler's method is the way she uses photography to dislodge and relocate the framework. By photographing not the individual work of art but rather the found situation, surroundings and spatial context, she destroys the boundaries of the work of art in favor of the photographed situation; the edges of the photograph "frame" the spatial situation as a whole, as an entity. Thus the individual works of art are no longer at the (literal and metaphorical) center of the photographs; instead, the relationships between the works of art and their locations, or the empty space between artworks, occupy the center. In most dealings with art there is an obvious hierarchy: the work of art as an aesthetically meaningful, necessary entity, set apart from its surroundings by a frame (or plinth), causes its chance, contingent, meaningless surroundings to fade away or become invisible. By contrast, Louise Lawler's photographs depict juxtaposed equals; all the elements shown inside the borders of an individual photograph are equal in value and importance, no longer arranged hierarchically. Thus Louise Lawler shifts the frame (replacing it with the frame of the photograph) and incorporates extraneous aspects such as the surroundings of the photographed artworks (or the spaces between them) into the heart of the photograph. And by this means the surroundings and the location loom into sight, indeed they become objects of perception; with the new borders that have been drawn, outside becomes inside, context becomes text, and background becomes figure.

The relocation of the frame can go on *ad infinitum* by photographing and exhibiting arrangements of photographs. In the early 1980s, Louise Lawler developed different types of arrangements of works, which show as much the arrangement as the different arranged works. In 1981, she made photographs of arrangements of works by artist-friends of hers on photographic backdrop paper, which were photographed and exhibited as photographs; so the pho-

tographic background had the same look, which was playing with the conventions of photographic "setting." Later she also began to create arrangements on the walls using her own photographs; in some, she arranged them in large blocks on monochrome painted sections of wall, so they were reframed in the actual situation.

When she photographs these scenes, the resulting pictures show a sequence of situations, surroundings or contexts enclosed within them, which logically are layered one on top of the other but which spatially are layered next to each other—as ever-new framings or surroundings. Constantly extending works of art to include frames, surroundings and entire situations leads to increasing confusion as to what the work of art is, and what is part of it; thus one can see clearly how a work of art is only recognized as such by virtue of the separation of inside and outside, of significant work and adjoining surroundings.

Louise Lawler's photographs uncover the hidden interests, desires and declarations of those involved in presenting works of art; her photographs are engaged in a project to illuminate perception, to elucidate the senses. They do not illustrate an analytical or sociological debate, but provoke insights by means of their own photographic configurations, by means of surprising flashes of recognition—for instance when the intentions and wishes of collectors or purchasers shine through a given situation. These photographs pave the way for flashes of situative recognition in the midst of the seemingly obvious and meaningless, which in turn lead to insights into the commercial, libidinous and discursive factors of evaluating art. Louise Lawler arrives at her illuminating discoveries with the help of a materialist "physiognomic" vision (as described by Walter Benjamin), which sees the general in the particular, the whole in the detail, the crucial interior in the apparently palpable exterior. Thus her photographs have a specific appeal that goes far beyond any documentary qualities: one's gaze will never exhaust their possibilities. Unlike documentary photographs which illustrate a debate, these photographs show more than they seem to—more than what is visible on the surface of the photographed situation and the photographs themselves.

The "profane illumination" of the physiognomic gaze generates recognition through an experience in which the familiar and the well-known become strange and telling. Just as dreams imbue objects and situations with strangeness and mystery, making it possible to see them "in another light," to perceive them at all, thus the gaze of profane illumination sees things and situations as though it had never seen them before. It experiences them as utterly alien and at the same time utterly familiar. Photography is, for Louise Lawler, the handmaid of the physiognomic gaze: it does not reveal by representing a work of art, but by showing it in its own revealing situation, where it has been placed by people who have linked it to their own interests and desires; she shows the work of art with its framing, context and location.

<div align="right">

Johannes Meinhardt
Translated by Fiona Elliott

</div>

PROMINENCE GIVEN, AUTHORITY TAKEN

An interview with Louise Lawler by Douglas Crimp

Douglas Crimp: Perhaps we should begin with your reservations about doing an interview, because it's my sense that those reservations will say something important about your work.

Louise Lawler: My reservations are about wanting to foreground the work and not the artist. The work works in the process of its reception. I don't want the work to be accompanied by anything that doesn't accompany it in the real world.

DC: Already in making a book of pictures, you're not presenting your work in the way that it usually appears. I know you've made choices about which pictures to publish, how to sequence them, what texts to print with them, so I suppose you are arranging your pictures in relation to one another similar to the way you might arrange pictures for an exhibition. But you're also capitulating to a type of presentation of your work that isn't one you would choose. Then again, you always work in complicity with already existing formats, and the book has been one of the most important sites of the art work's circulation for the whole of the past century.

LL: By titling this book *An Arrangement of Pictures*, I mean to acknowledge that there is a difference between what is shown on these pages and how these pictures exist in various formats and sizes in my work. In the book they straddle a line between representing my work and the information contained within the pictures themselves. As carriers of information they function as journalism. When I took on the position of photo editor with Brian Wallis for *Art after Modernism: Rethinking Representation*, and when my photographs accompanied your essays in *On the Museum's Ruins*, the fact of making meaning by juxtaposition and alignment was even more explicit. Some of the pictures that I took and used in these and other publications are also works independent of the publications; others are not.

DC: Often an interview takes artistic intentionality too much for granted: it assumes that the artist fully knows what he or she is doing and can control the meaning of the work. But interviews can also supplement knowledge. In a book of your photographs, a number of things about your practice would be invisible, starting with the fact that much of your work is not photographic at all. Some of your work consists of text circulated by various means; some consists of objects of various kinds; most of it appears in the form of installations; some of it is collaborative. In your first exhibition, at Artists Space in 1978, you showed a picture that wasn't your own, and it wasn't a photograph.

LL: In fact I once thought about trying to compile a record of what I've done in the form of straightforward descriptions. I don't object to providing information about the work, but to giving it an interpretation. I wanted to describe, for example, what the situation was at Artists Space because that situation did produce the work. The situation is always part of what produces the work for me.

DC: Perhaps it would help clarify what you mean to explain what that situation was at Artists Space.

LL: Okay, the art world audience is a very small part of the public at large, and the audience of Artists Space was a very small part of even that art world audience. It consisted of younger artists interested in seeing another younger artist's work. The gallery was in a part of downtown Manhattan that we now know as Tribeca but at the time it was just an area of mostly butter and egg warehouses. Artists Space was on the second floor of its building, so you wouldn't be likely just to come across it and stop in, but it had a reputation as a legitimate point of entry into the art world, a place for a young artist's work to become visible. Four artists were invited to participate in this show, organized by Janelle Reiring. Christopher D'Arcangelo and I discussed the possibility of convincing the other artists that all our work would appear under the guise of a one-person show, with work by one of the four of us, and each of us would claim that the work was ours. We didn't succeed.

Chris's work for the show consisted of withdrawing his name from the announcement and any other advertising. You wouldn't know about his work, as his work, unless you came to Artists Space. We were each given four pages in the catalogue; he wrote a text that was a typeset to fit but left his catalogue pages blank and glued the text to the walls in various rooms at Artists Space. I went a different way. I borrowed a painting from Aqueduct Race Track, which represented another small, insular community of interest—one that also happens to own a large collection of paintings. Portraits of racehorses mostly commissioned by their owners (I was interested in other reasons for collecting art works than the ones we in the art world normally think about). An oil painting of this age and style was one of the last things you'd expect to see at Artists Space at that time. I rented stage lights and placed them above the painting, one directed at the viewer and another directed through the space. This made the gallery glaringly white and projected the shape of the windows onto the street façade of the building across the street, including silhouettes of people when they were in the space. The spotlights were left on until midnight. It was a very corny way of letting people at street level know that something was going on upstairs. I also designed a logo for Artists Space and used it as the cover of the catalogue. I was trying to "show" the space, to open it up to an audience beyond its usual one, and at the same time to bring something into the space that represented another community whose interests wouldn't usually have been considered at Artists Space. I wouldn't have done such a work if Artists Space hadn't been where it was and what it was.

I don't think people really understood what I was doing in that exhibition, even though it wasn't so different from my first show at Metro Pictures. But there I stepped back, and I provided a picture. When Metro asked me to do a show in 1982, they already had an image. They represented a group of artists whose work often dealt with issues of appropriation and was often spoken of and written about together. A gallery generates meaning through the type of work they choose to show. I self-consciously made work that "looked like" Metro Pictures. The first thing you saw when you entered my show, Arrangements of Pictures, was an arrangement of works the gallery had on hand by "gallery artists" Robert Longo, Cindy Sherman, Jack Goldstein, Laurie Simmons, and James Welling. A wall label titled it "Arranged by Louise Lawler." It was for sale as a work with a price determined by adding up the prices of the individual pieces, plus a percentage for me. I went to the collectors to whom Metro had sold work and photographed the Metro artists' works in those contexts. I printed the resulting images a "normal" picture size and titled them "arrangements," too—for example, "Arranged by Barbara and Eugene Schwartz, New York City." The Metro situation at that time formed that work, and it also formed a way of working for me.

DC: Having this sort of information is very clarifying; it isn't reductive.

LL: The problem is that you say what's easiest to say or what you can be most articulate about, which neglects other aspects of the work, because you can't talk about everything. It's a matter of focusing, and focusing the meaning of the works limits its reception for the viewer—it's like the phrase I printed on one of my drinking glasses, "It's something like putting words in your mouth." Then again, if I were to do a book of very accurate captions giving all the pertinent information about the situation in which the work initially appeared, it would seem fetishizing. That would limit the work's meaning in another way. Of course, there's also what else is cut there, which is part of how the work is received, too. The work can never be determined just by what I do or say. Its comprehension is facilitated by the work of other artists and critics and just by what's going on at the time.

DC: As I understand what you're saying, your resistance is to forms that pretend to authenticity, whether that of the artist's voice saying, "This is what I intended," or the careful description of initial context, which implies that it's only the moment for which the work was originally made in which the work achieves its meaning. And neither of these things can be true. The work will always exceed both of these things.

LL: You know, I'm not even comfortable taking photographs when I know what I'm taking. I feel as if approaching something with too much clarity in advance could eliminate possibilities. Sometimes you have to give something up in order to get it right. And sometimes you hold onto the wrong things. Speaking about the work can make it seem programmatic, whereas what actually produces the work is not a program, but the activity of producing it, having to make adjustments as you proceed. Talking about work isn't like that, because it's hindsight.

DC: It's true that the easiest things to say about your photographs are of a programmatic nature—that they're about the art work's framing conditions, about the commodity structure of the art world and so forth. And this produces a certain dryness, a reduction of the work to its function as institutional critique. While these things may be true and accurate about your work, they don't capture something else that's crucial.

There's a word that you often use to describe things: "poignant." I've come to associate your use of that word with one of my favorite of your works, the two identical photographs taken at Christie's of a Warhol Marilyn, one with a caption that asks, "Does Marilyn Monroe Make You Cry" and the other with the caption "Does Andy Warhol Make You Cry." The word "poignant" means both "pointed," "sharp," "focused," and "affecting," "moving." So the word captures dimensions of your work comprising not only its pointedness, its criticality, but also something much more difficult to speak about, its emotional effect. I find this particularly interesting with regard to this work, because we so easily think of Marilyn Monroe as a heartbreaking figure, but then what about Warhol? Does he affect us in the same way? How are we affected by what is so often called his affectlessness?

LL: Even the fact that we call these people "Marilyn" and "Andy" has a certain poignancy, indicating that we want somehow to be closer to them, while what we really have an intimacy with is those pictures. And the poignancy also extends to the painting itself. It's been removed from the intimacy of someone's bedroom, and here it is on the wall of an auction house.

When I'm working, I take lots of pictures. It's a way of working that's fairly flatfooted in that I have a sense that something is worthwhile documenting, but the pictures that work are those that are affecting in some other way.

DC: I think there's a tendency to assume that if work has a critical dimension it forgoes all those other qualities that we associate with art, and, of course, this isn't true because if it were, critical art works wouldn't work: they wouldn't work on us, we wouldn't connect to them. We'd just say, "I get the point." The point has eluded us. We didn't already know this. Your works make us think differently, partly by making us understand our own implication in things and how ambivalent we often feel about this world we devote ourselves to—how critical we feel of the art world, how alienated from it we feel, but also how thoroughly we're drawn to it. It seems like your use of language is much like your use of pictures.

LL: I'm trying to reposition the viewer with both. Some of my language is very straightforward, more or less exact technical or visual descriptions, such as calling a picture "green." Sometimes it's a question of connecting a picture with a quotation that relates to its reception, such as the one accompanying the photograph of Degas's Little Dancer, which comes from the time that Degas first exhibited the work and shows a very different relationship to the work than we have today. I try to give some information—for example, calling a photograph of sculpture "Objects"—that will make you rethink what you're told. You're told something about it, but certainly not everything. Sometimes the text is just a title, sometimes it's printed on the wall, and sometimes on the photograph's mat. So the text is a part of the work, but it's not always a prominent part of the work.

DC: Do you change a text's relation to a work in different contexts?

LL: That's happened in certain exhibitions, such as The Decade Show at the New Museum in 1990, for which I wrote a text imitating the kinds of texts that museums have at the entrance of an exhibition. That text accompanied that particular photograph that one time.

DC: What about the more elliptical texts, like "Once There Was A Little Boy and Everything Turned Out Alright, The End."

LL: Well, I guess that's the height of poignancy. That was a found text. My mother copied it from the wall when we were sitting in a booth at a roadside café. The picture that the text goes with was taken in St.-Germain-en-Laye, outside Paris. The paintings I photographed just seemed like generic 1950s French art to me—I didn't know what they were at the time—but the picture had to do with the whole situation—for example, the mistletoe hanging from the chandelier. And I often show that picture with another one that is accompanied by the text "Paris, New York, Rome, Tokyo." Both the photographs and the texts have a certain kind of symmetry. Both photographs are taken in homes, so it seemed interesting to juxtapose them; meaning is also made through juxtaposition. There are some cases in which an identical picture is shown with two different texts, and they're shown in different locations, so you see the picture related to one text, and then you see it again with another text. I'm playing with the fact that when you see something for a second time, it's different from seeing it the first time. The recognition factor changes perception. And the same is true of the texts. Often there's something familiar about the text, about the language I use, which points to situations that are already familiar, or maybe not, so I'm alluding to things that make you comfortable and uncomfortable. Something is what you expect, but then not quite, so where do I leave you?

DC: Your texts don't always appear in relation to pictures. They also show up on drinking glasses, matchbooks, stationery.

LL: Art works get a special kind of attention, because that's what they're made for, but to slip something in on a matchbook or a napkin can also be useful. It's a way of putting loaded information in a place where you wouldn't expect it, to give attention to other ways of producing meaning without always having to be so artlike. I'm trying to say somehow that the rest of the world counts, even though I know it doesn't seem like that at all, because most of my work appears to be about the art world.

DC: You've done a lot of collaborative work.

LL: Collaboration involves a different attitude about what makes an artwork. I've said before: "Art is part and parcel of a cumulative and collective enterprise viewed as seen fit by the prevailing culture." A work of art is produced by many different things. It isn't just the result of an unencumbered creative act. It's always the case that what is allowed to be seen and understood is part of what produces the work. And art is always a collaboration with what came before you and what comes after you. Working collaboratively allows you to do things that you wouldn't otherwise do. You think about another person's thinking as well as your own, and this acts as an acknowledgment that no work is really produced by one person. Sherry Levine's and my "A Picture Is No Substitute for Anything" came at a time (1981-82) when there wasn't much question about whether to show in a gallery—I mean, no one was asking us to show. So declaring our own gallery was also a way of showing that a gallery isn't just a showcase, it's also what's on display. We weren't being subsumed as part of a gallery, we were the gallery. Our announcement cards always looked the same, but our shows were always in different places, usually just for one night, which emphasized a salon quality. It was basically a matter of agreement. When Allan McCollum and I collaborated on "For Presentation and Display: Ideal Settings" in 1984, we wrote the press release in the third person, writing it as if it were about someone else. It was another effort to step back, to include and show what was already there.

DC: It was a different era when you could assume a public that would recognize an art work in such an ephemeral event as the one in 1981 in which you sent out invitation cards inviting people to go on a particular night to see New York City Ballet's *Swan Lake* ("Tickets to be purchased at the box office"). And before that there was "A Movie without the Picture," which you first did at the Aero Theater in Santa Monica in 1979. You used *The Misfits* on that occasion, but didn't you substitute Godard's *Contempt* for the New York version?

LL: No, a still from *Contempt* was one of the pictures on the poster. In New York I showed *The Hustler*, and before it, the cartoon *What's Opera, Doc?* I selected movies that had a particular aura for people of our generation or, in the case of *The Misfits*, for people slightly older that we are. Marilyn Monroe, Clark Gable, and Montgomery Clift all died after *The Misfits* was finished, so this film was very loaded emotionally. I was interested in what it's like being part of an audience for something, whether you're alone looking at a book, in a gallery surrounded by other people looking at the same picture as you, or in that particularly passive situation of sitting in the dark, eyes glued to the screen, allowing yourself to laugh more when others do. It was important to me that everything proceeds normally, but there would be a single difference, which was announced: "A movie will be shown without the picture." You weren't told what the movie was.

DC: What about the artists' bird calls piece? Was that a self-consciously feminist work? I know it's been written about that way and that all the artists whose names are turned into bird calls are male.

LL: That work originated in the early 1970s when my friend Martha Kite and I were helping some artists on one of the Hudson River pier projects. The women involved were doing tons of work, but the work being shown was only by male artists. Walking home at night in New York, one way to feel safe is pretend you're crazy or at least be really loud. Martha and I called ourselves the "due chanteusies," and we'd sing off-key and make other noises. Willoughby Sharp was the impresario of this project, so we'd make a "Willoughby Willoughby" sound, trying to sound like birds. This developed into a series of bird calls based on artists' names. So, in fact, it was antagonistic, but more an instinctual response than a programmatic effort at first. I redid and recorded the bird calls in 1982, which was another time when artists with names recognition seemed to be dominantly male, so I added some names from that time, like Cucchi and Clemente.

This question of name recognition relates to my feelings about interviews, to the credibility that is given to a statement because of who is speaking. When I worked at the Castelli Gallery in the 1970s, I put aside clippings that came into the gallery that I wanted to read, but often I'd have to leave the first page of the article for the gallery's archive. I remember there was one long interview in which the speakers were "CT" and "MM" which I read as Cy Twombly and Marilyn Monroe (it was actually Carolyn Tisdale and Mario Merz). Along the same lines, I fantasized about being interviewed by Dick Cavett, but realizing that no one would care about what I thought, I planned to write a script and ask Marcello Mastroianni to play me. The funny thing is, he was working on a movie in my neighborhood at the time. So I was thinking constantly about his playing me on the Dick Cavett show, but then when I'd actually see him and make eye contact, I was too nervous to speak to him.

There is a related piece that I wanted to do at the Castelli Gallery, in which I planned to replace everyone who worked there with actors. I planned to place an ad in *Variety* that would say "Matinée: Leo Castelli Gallery" and give the date and say who was playing whom. Diane Keaton agreed to do it. But I realized there was a basic flaw in my plan, because when you got off the elevator and saw Diane Keaton behind the desk, you wouldn't walk up to her and ask to borrow slides.

DC: In fact, the person to whom we grant the greatest credibility regarding a work of art is the artist who made it. In your case, though, a reticence about taking on the conventional role of the artist, your oblique approach to making works, is, in a sense, the very content of your work. You could say with regard to your work that a doubt about, or lack of confidence in, what you're doing—what one would normally think of as working against productivity—these things are actually what make your work possible, make you produce it in the first place.

LL: I try sometimes to show that in the work, for example in my show at the Monika Sprüth Galerie in Cologne in 1999, Hand On Her Back and Other Pictures. "Hand On Her Back" is the name of one of the works in the show. Its title can be read as either comforting or pushy, while the phrase "and Other Pictures" both gives prominence to that picture and takes it away at the same time. I did a drinking glass that said "Prominence given, Authority taken." Perhaps that sums up my resistance.

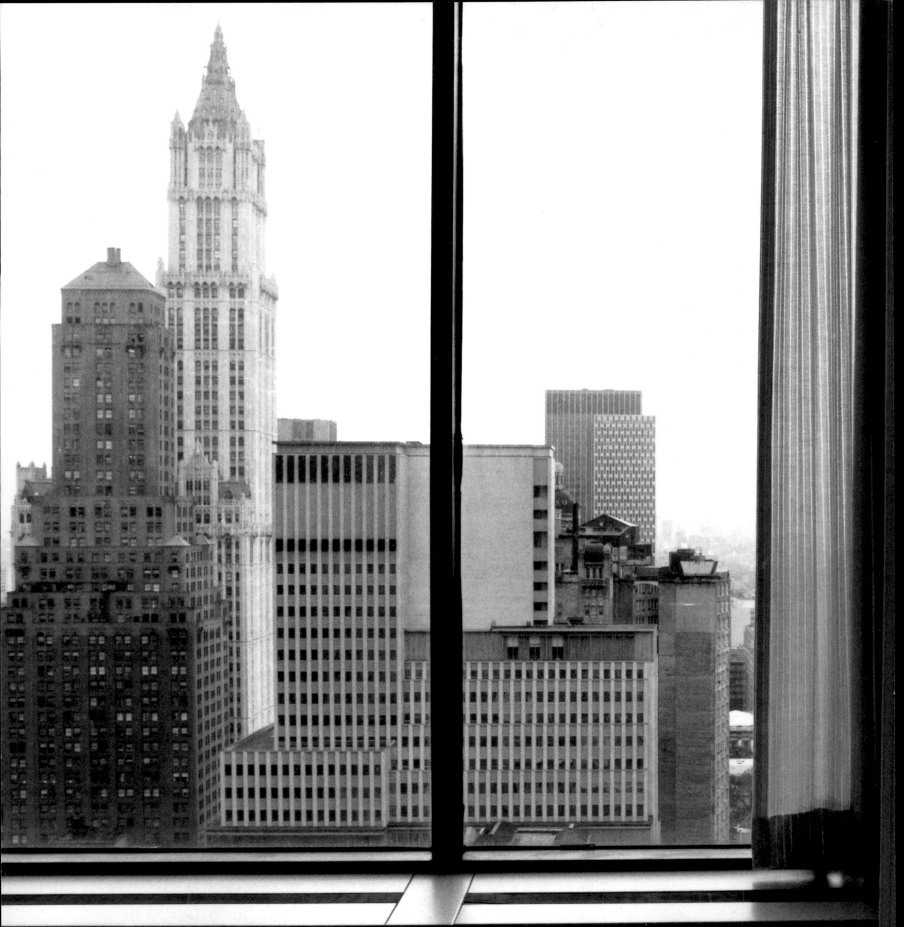

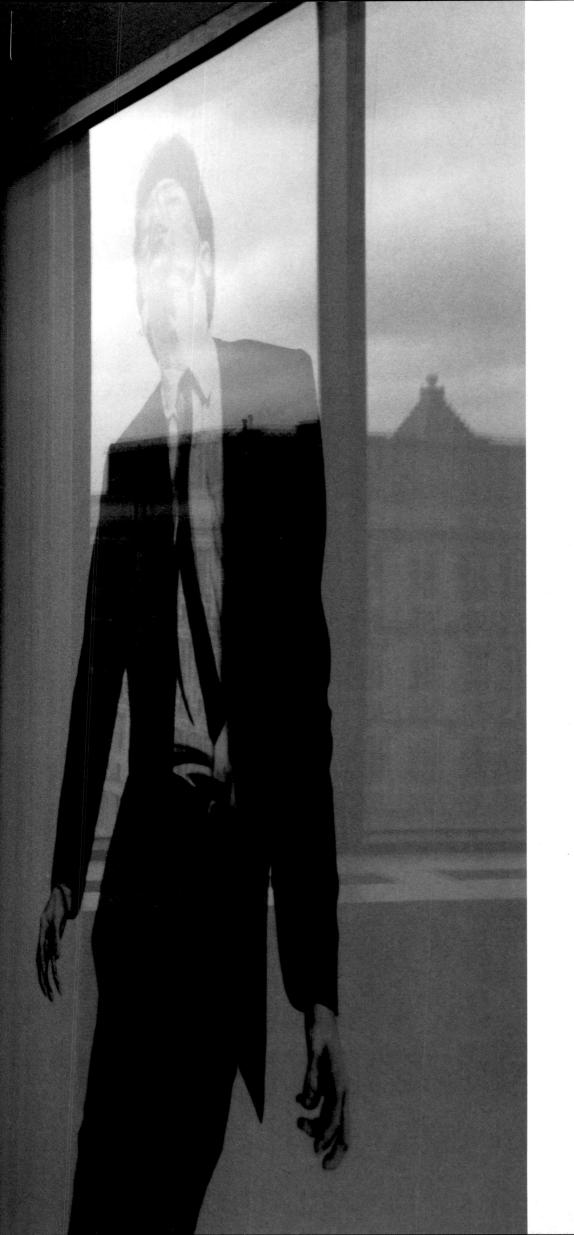

Arranged by Donald Marron, Susan Brundage, Cheryl Biship at Paine Webber, Inc., 1982

black and white photograph, 17 ¹/₄ x 23 ¹/₄"

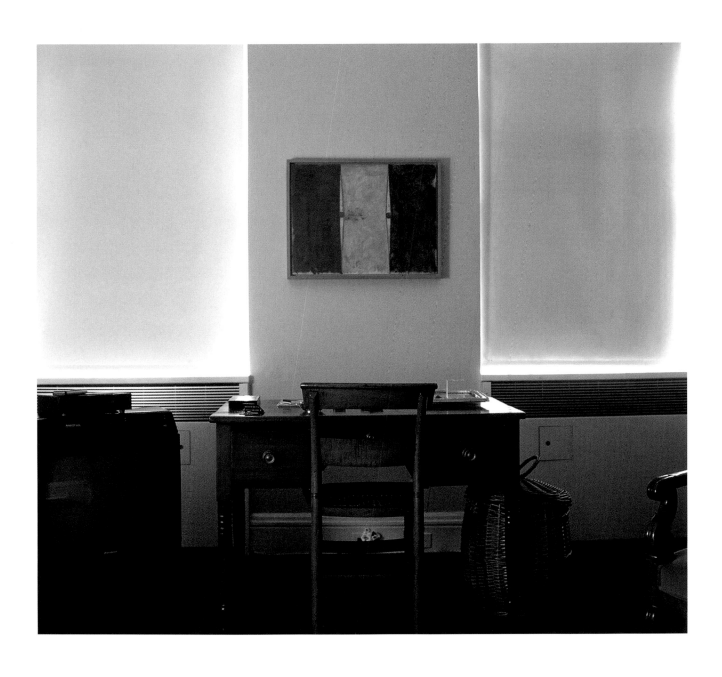

Overlooking Central Park, 1994

cibachrome, 17³/₄ x 19³/₄"

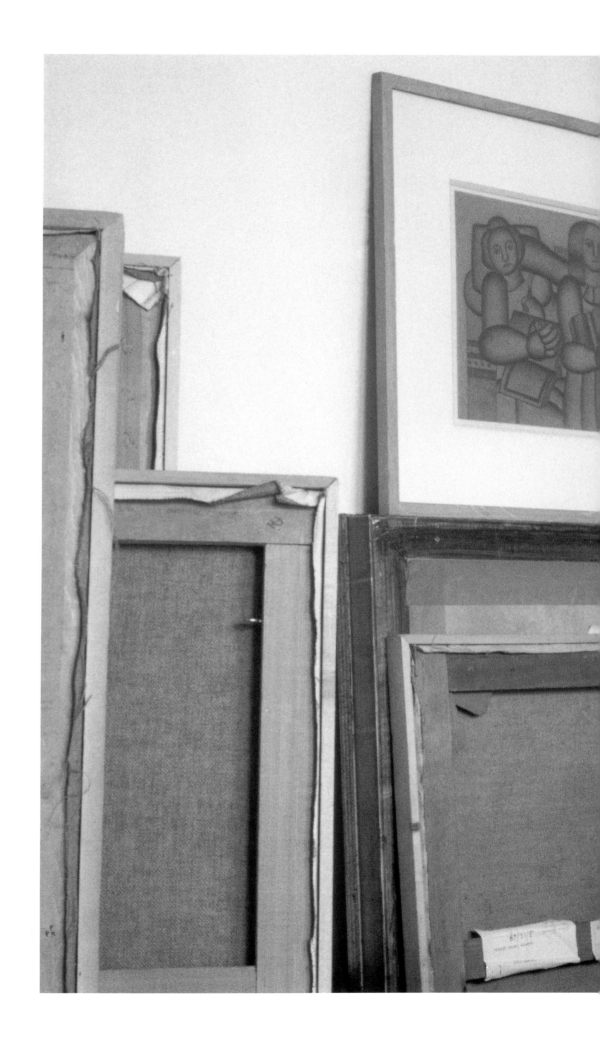

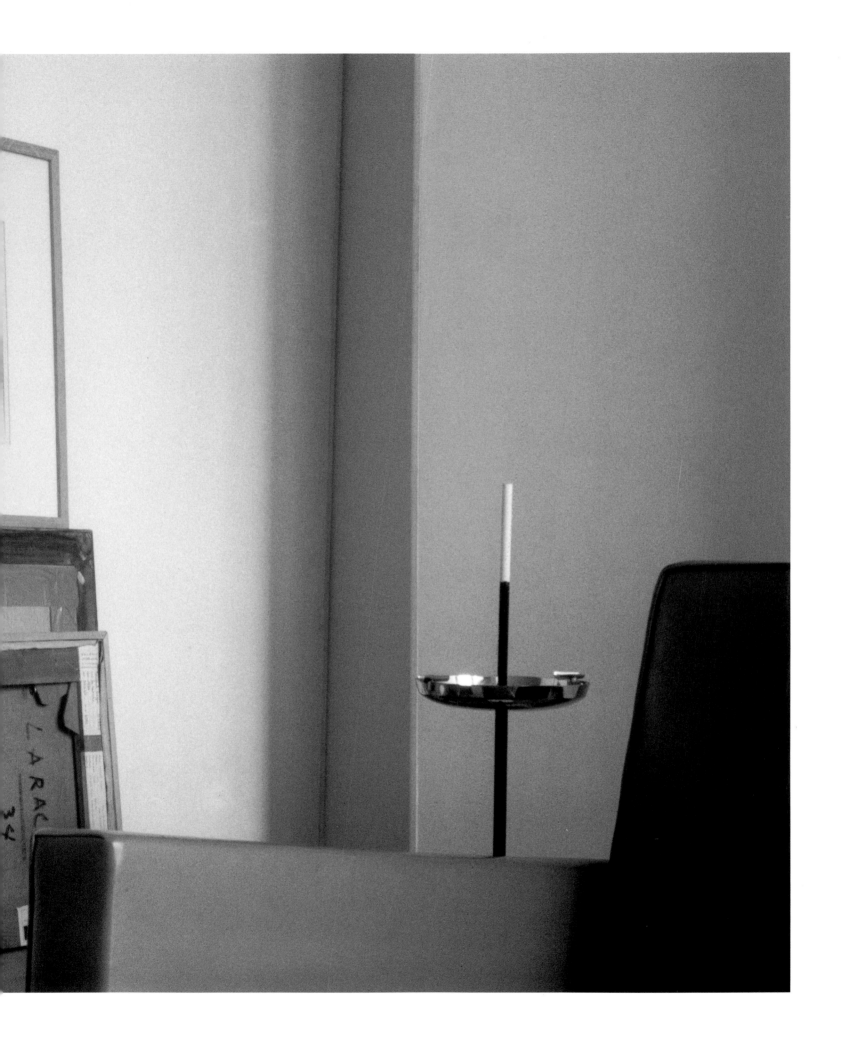

This Drawing is For Sale, 1985
cibachrome, 25$^{1/2}$ x 38"

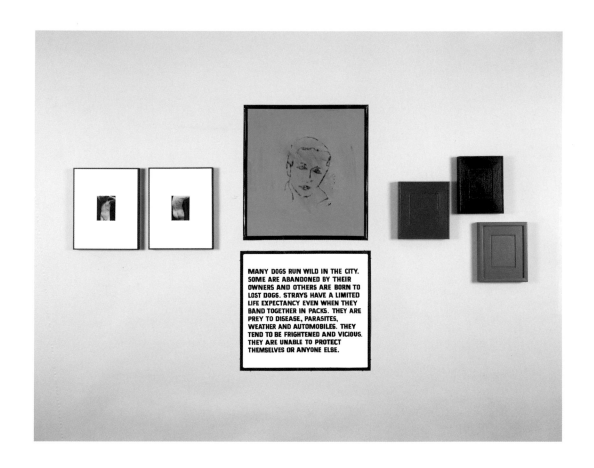

(Allan McCollum and Other Artists) Lemon, 1981

cibachrome, 28¹/² x 37¹/⁴"

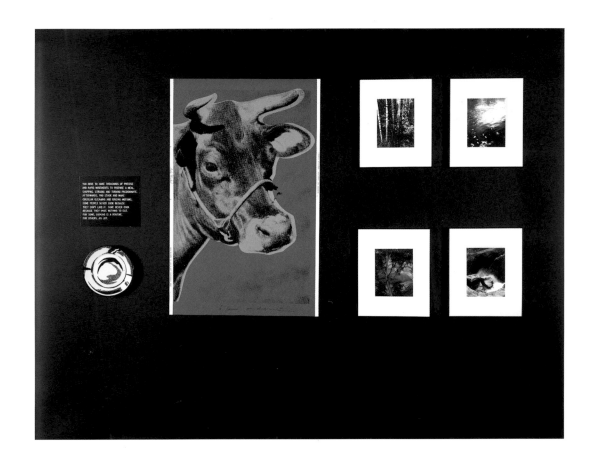

(Roy Lichtenstein and Other Artists) Black, 1982

cibachrome, 28¹/² x 37¹/⁴"

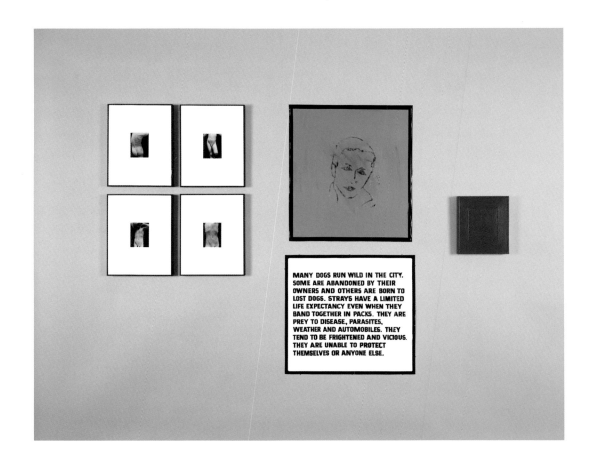

(Holzer, Nadin and Other Artists) Baby Blue, 1981

cibachrome, 28¹ᐟ² x 37¹ᐟ⁴"

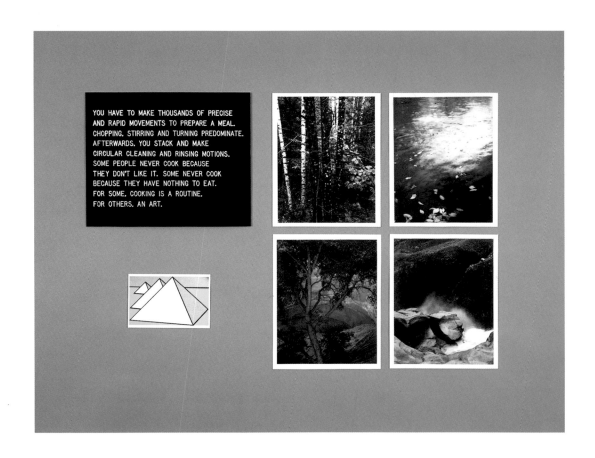

(Jenny Holzer and Other Artists) Kelly Green, 1982

cibachrome, 28¹ᐟ² x 37¹ᐟ⁴"

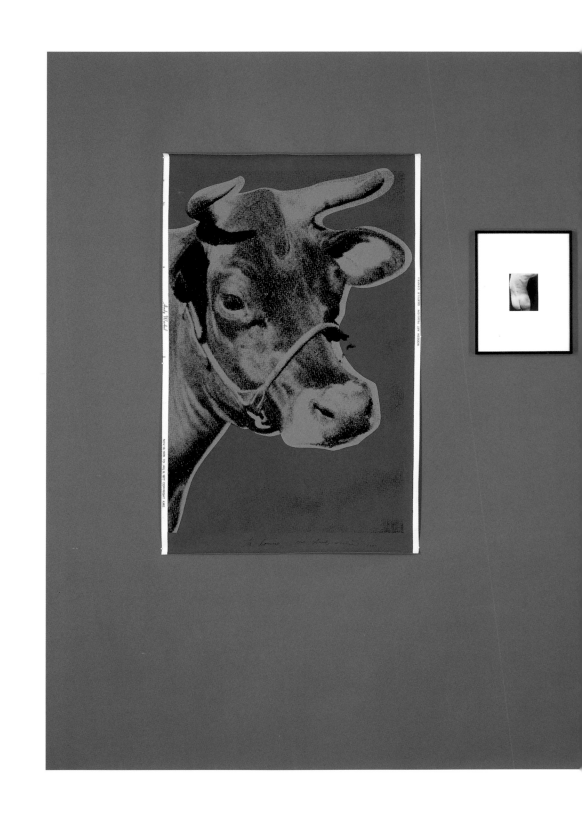

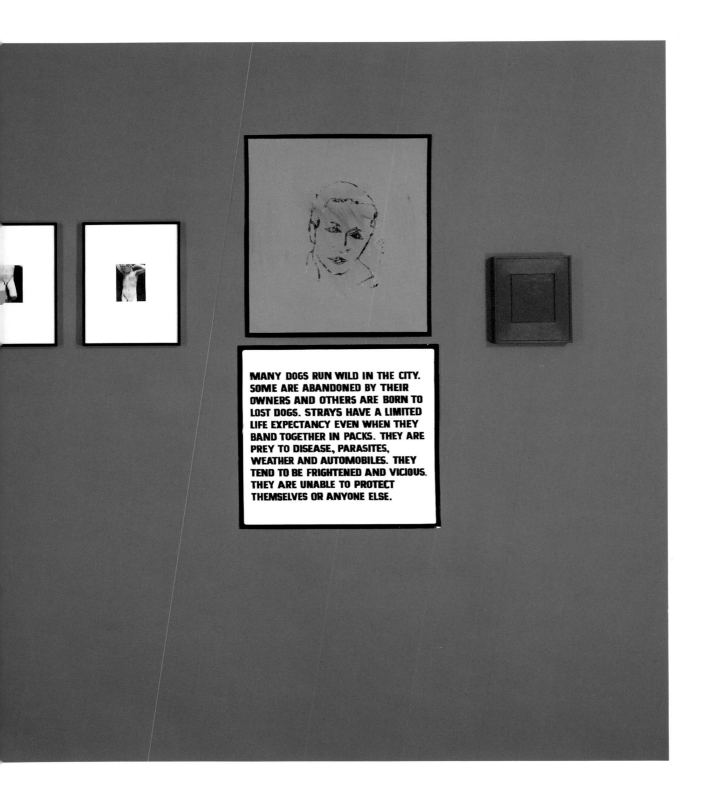

MANY DOGS RUN WILD IN THE CITY.
SOME ARE ABANDONED BY THEIR
OWNERS AND OTHERS ARE BORN TO
LOST DOGS. STRAYS HAVE A LIMITED
LIFE EXPECTANCY EVEN WHEN THEY
BAND TOGETHER IN PACKS. THEY ARE
PREY TO DISEASE., PARASITES,
WEATHER AND AUTOMOBILES. THEY
TEND TO BE FRIGHTENED AND VICIOUS.
THEY ARE UNABLE TO PROTECT
THEMSELVES OR ANYONE ELSE.

(Andy Warhol and Other Artists) Tulip, 1982
cibachrome, 38¹⁄² x 60¹⁄²"

Board of Directors

black and white photograph with text on mat
(image) 16 x 22¼"
(mat) 28 x 32¼"

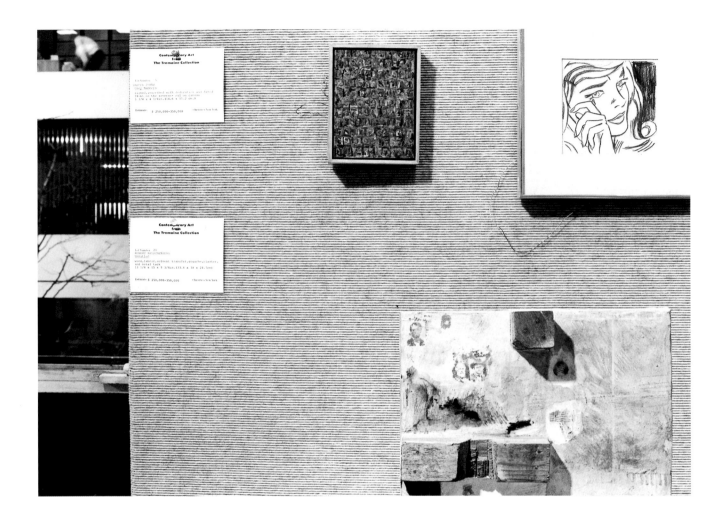

Conditions of Sale, 1990

black and white photograph with text on mat
(image) 15 1/2 x 22"
(mat) 28 x 32"

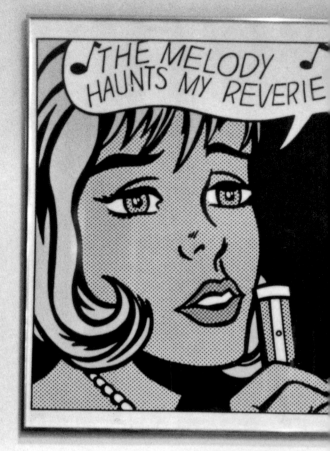

Arranged by Donald Marron, Susan Brundage,
Cheryl Biship at Paine Webber, Inc., 1982

black and white photograph with text on mat
(image)19 ¹⁄₂ x 21 ³⁄₄"
(mat) 28 x 32"

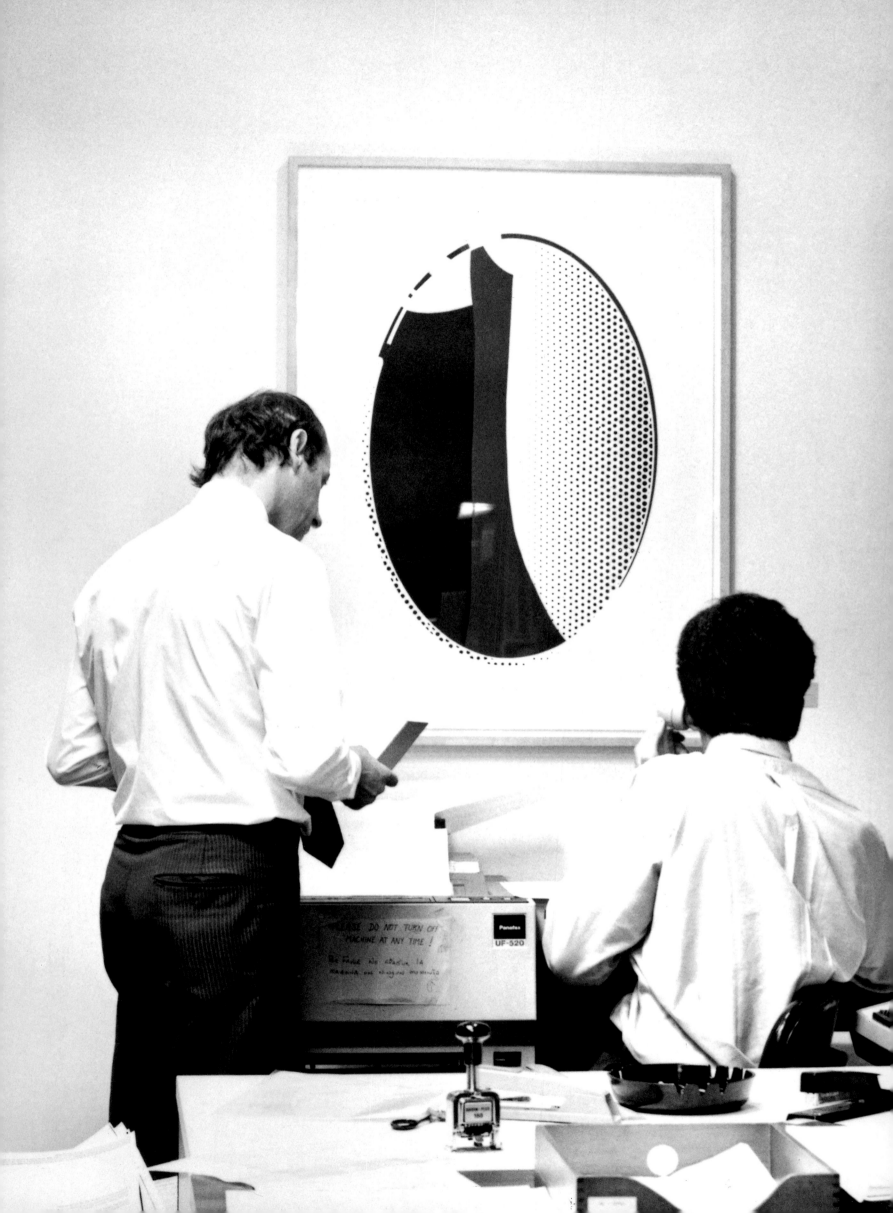

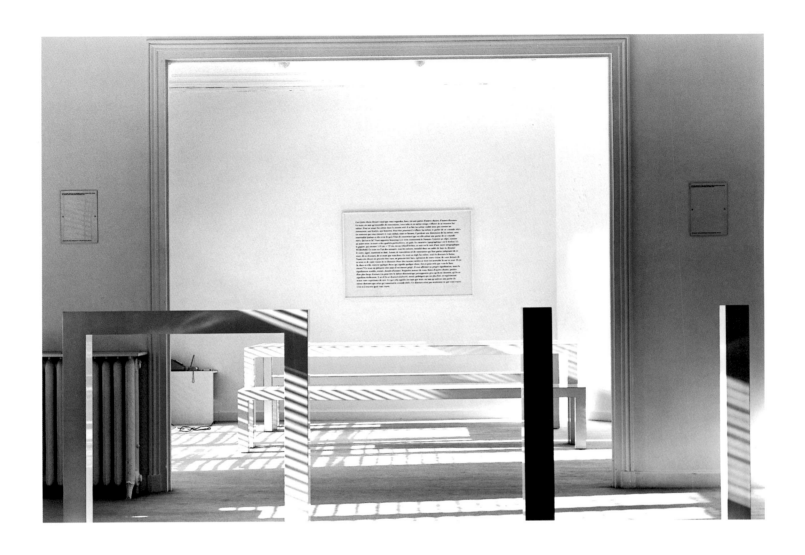

Paris, New York, Rome, Tokyo, 1985
black and white photograph with text on mat
(image)15¹/² x 23"
(mat) 28 x 32"

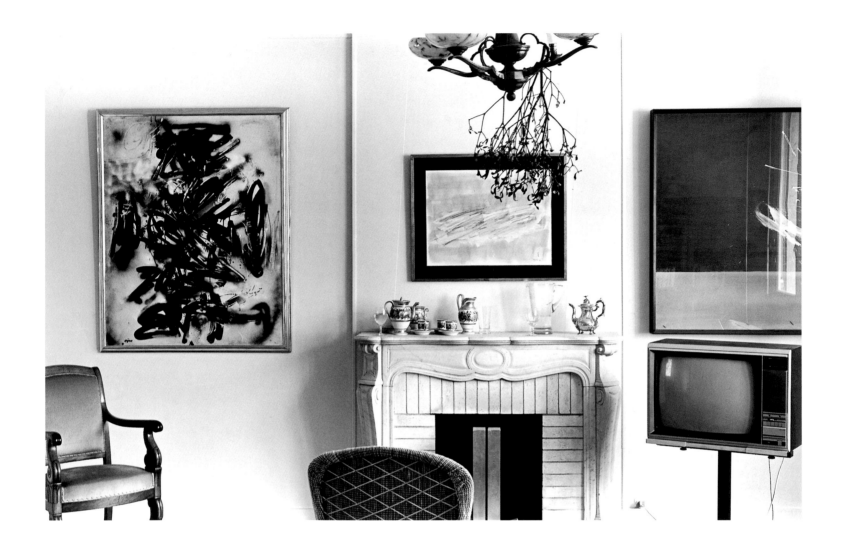

Once There Was A Little Boy and
Everything Turned Out Alright, The End, 1985

black and white photograph with text on mat
(image) 15¹/₂ x 23˝
(mat) 28 x 32˝

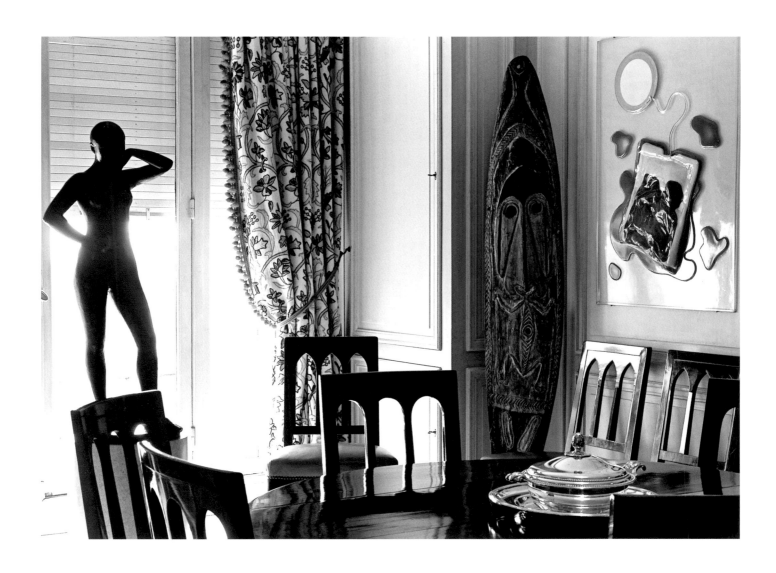

In the 16th Arrondissement, 1986/88

black and white photograph with text on mat
(image) 20 x 24"
(mat) 28 x 32"

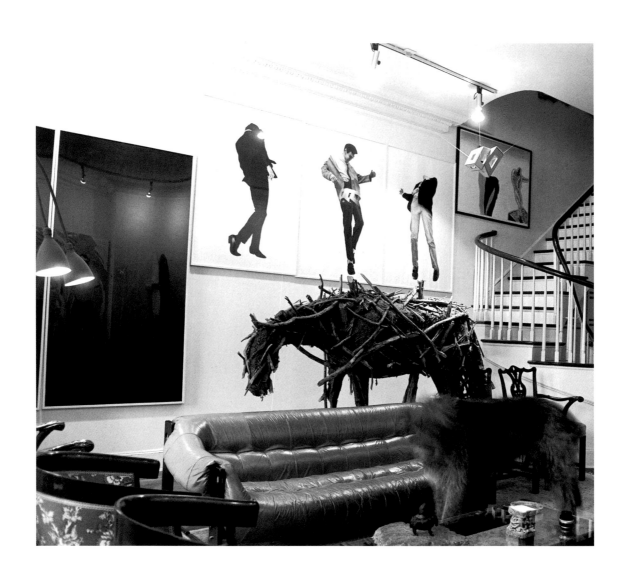

Arranged by Mera & Donald Rubell, 1982

black and white photograph with text on mat
(image) 21¹ᐟ² x 19¹ᐟ²"
(mat) 28 x 32"

Alligator, 1985

cibachrome, 25$^{1/2}$ x 38$^{3/4}$"

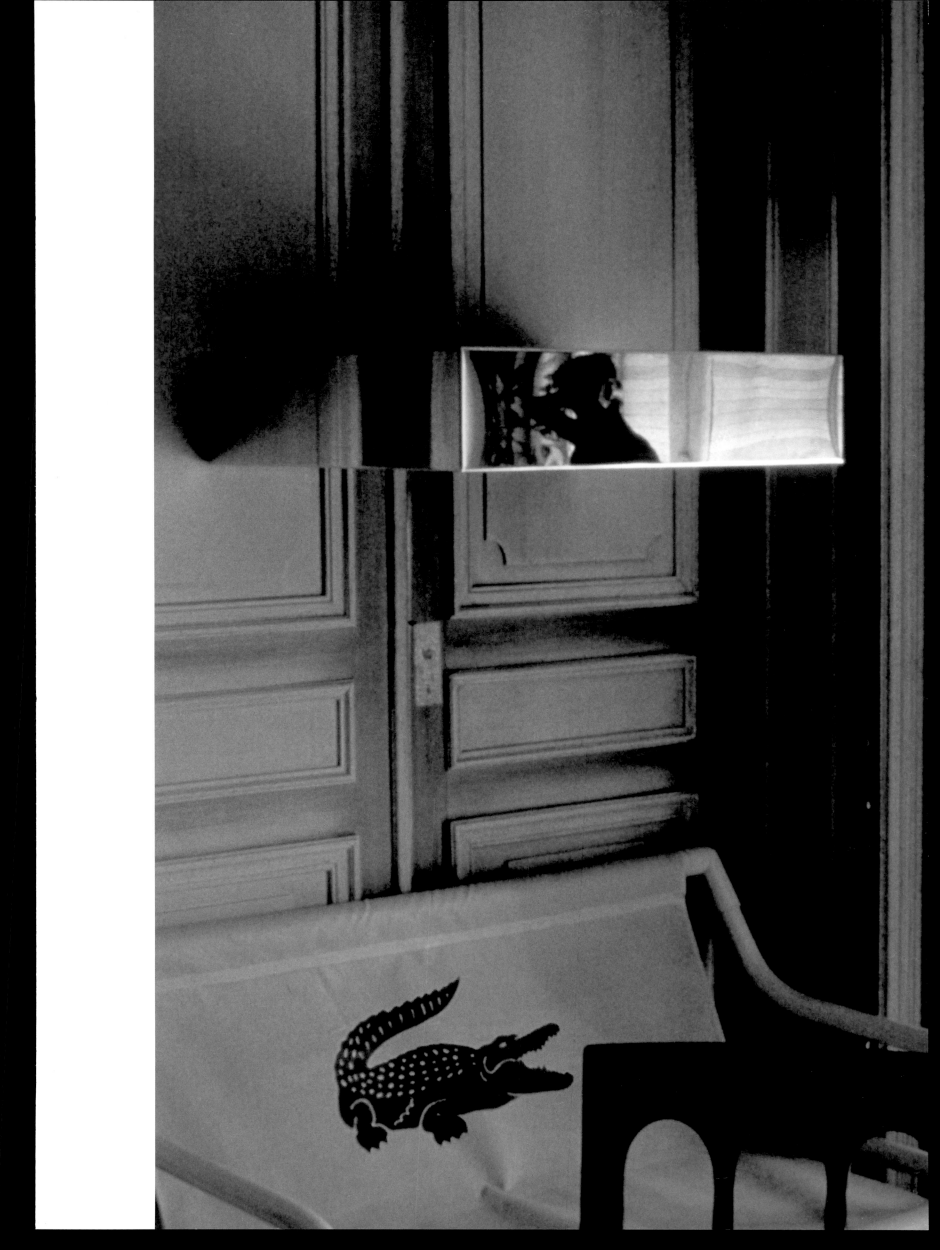

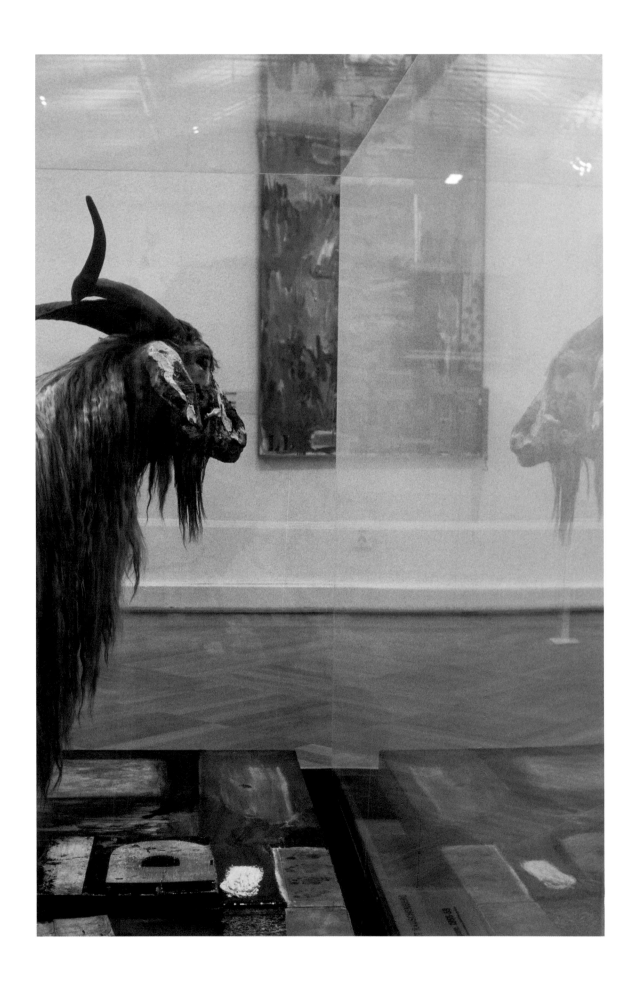

Untitled, 1987

cibachrome, 27³/⁴ x 39¹/⁴"

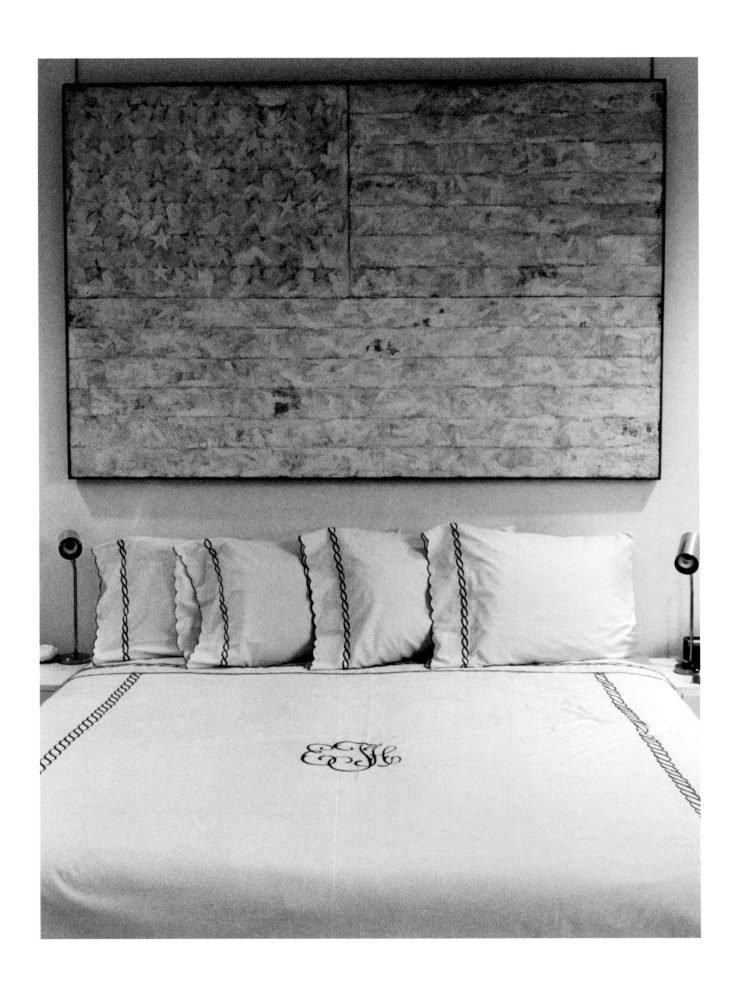

Monogram, 1984

cibachrome, 28 x 39$^{1/2}$"

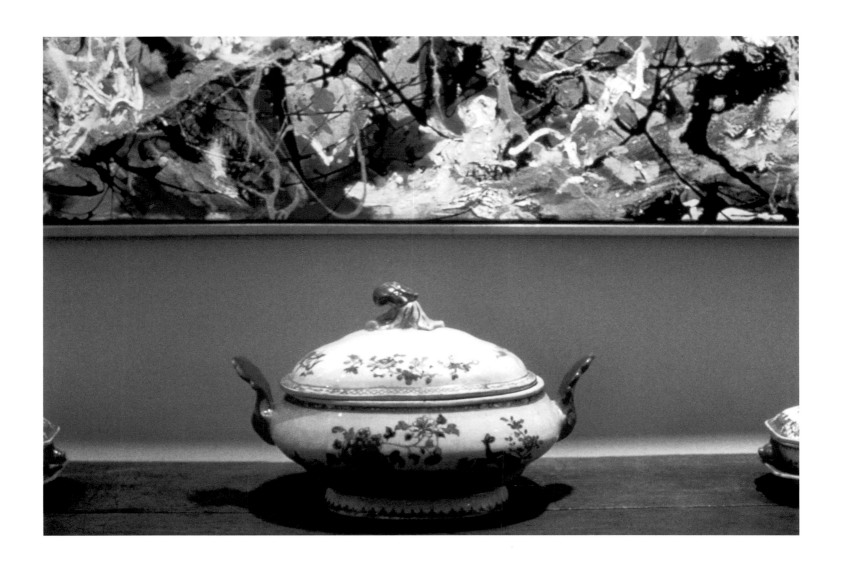

Pollock & Tureen,
Arranged by Mr. & Mrs. Burton Tremaine, Connecticut, 1984

cibachrome, 28 x 39"

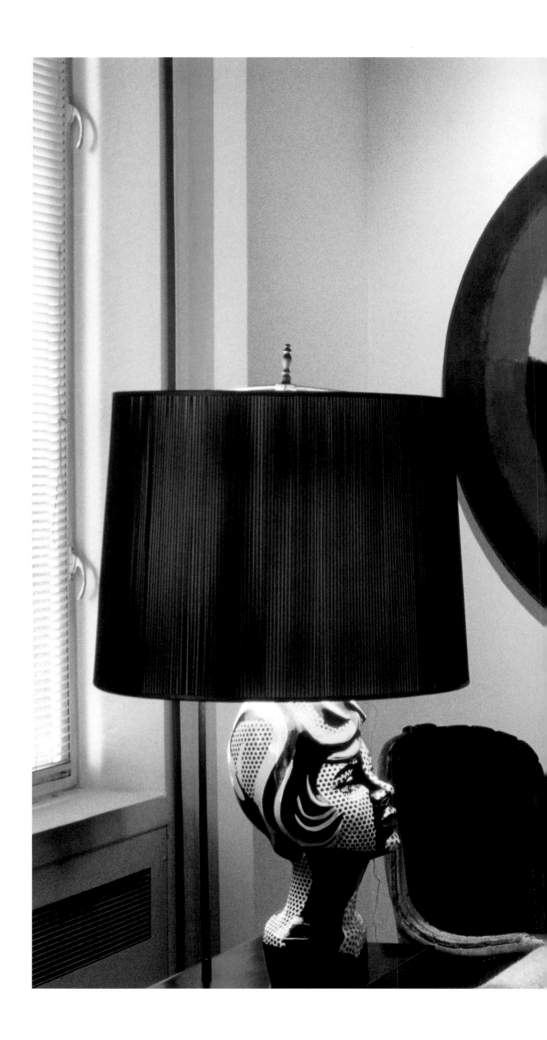

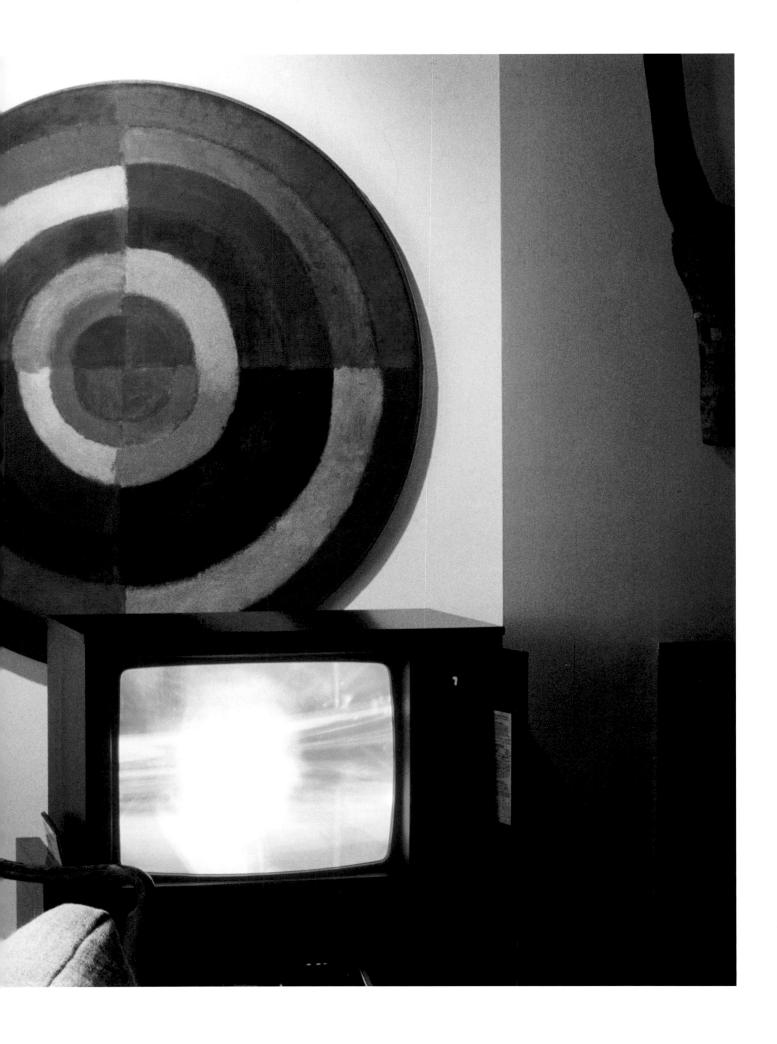

Living Room Corner,
Arranged by Mr. & Mrs. Burton Tremaine, New York City, 1984

cibachrome, 30 x 40"

BOUGHT IN PARIS, NEW YOR

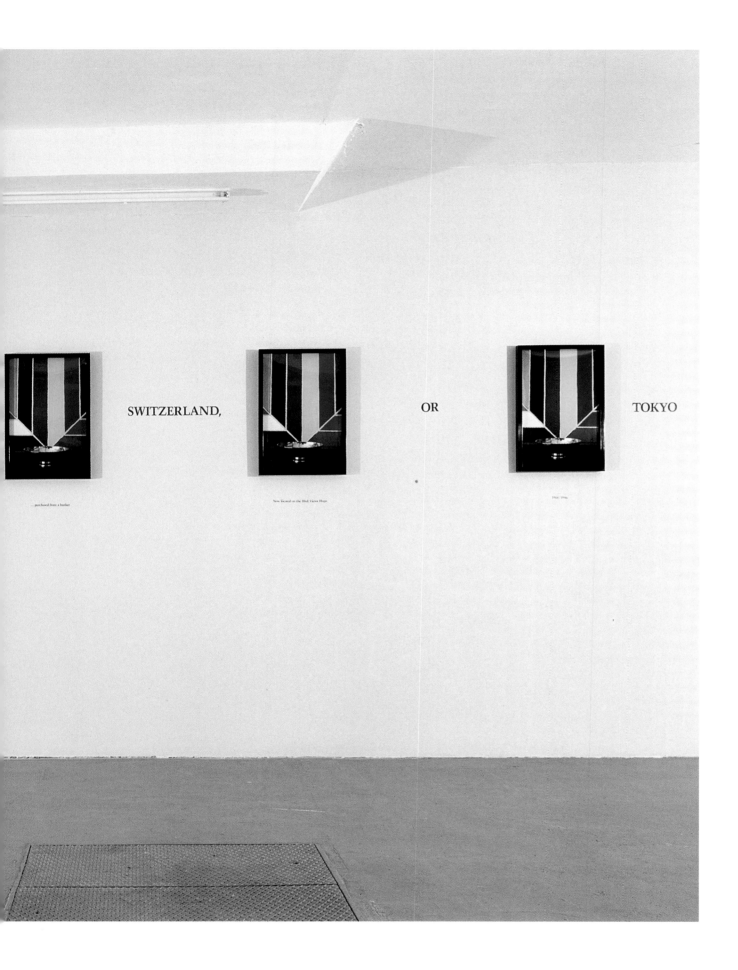

Bought in Paris, New York, Switzerland or Tokyo, 1987
Stella/Brass, (detail) Les Indes Galantes IV, ...purchased from
a banker, now located on the Blv. Victor Hugo, 1966/86

five cibachromes plus text on wall
28$^{1/2}$ x 283"

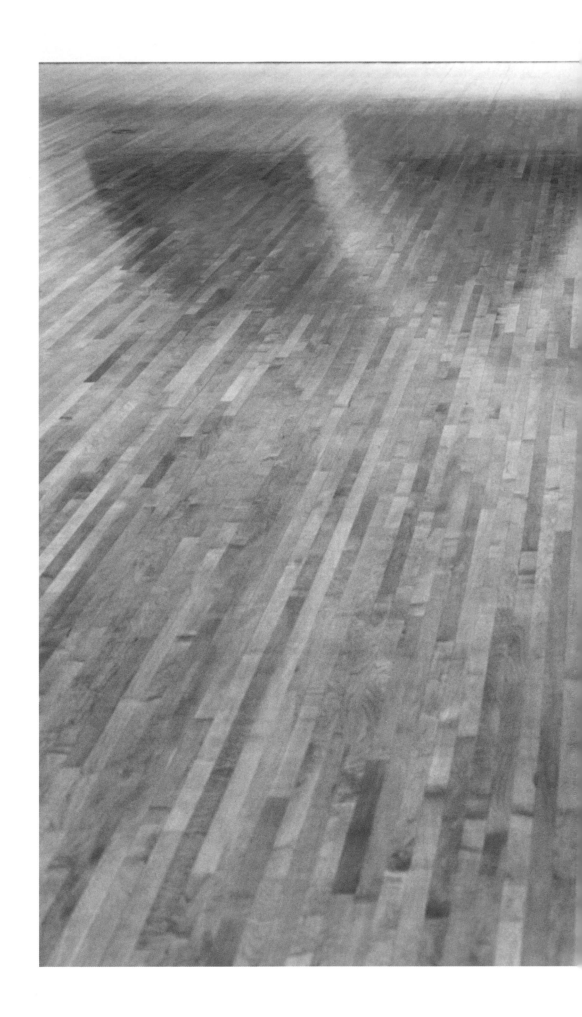

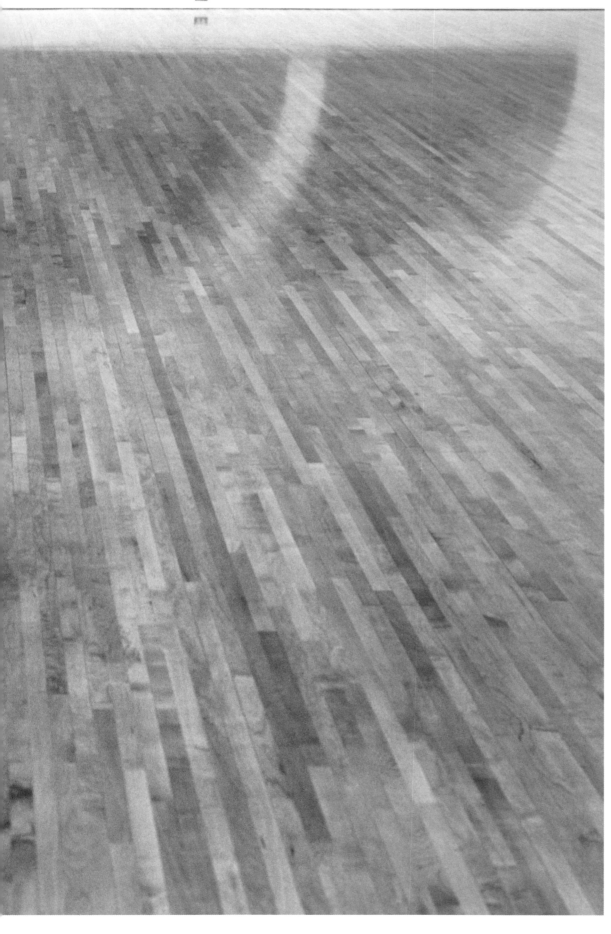

How Many Pictures, 1989

cibachrome, 61⁷/₈ x 48¹⁵/₁₆"

Woman With Picasso, 1912, 1986
cibachrome, 26 x 38"

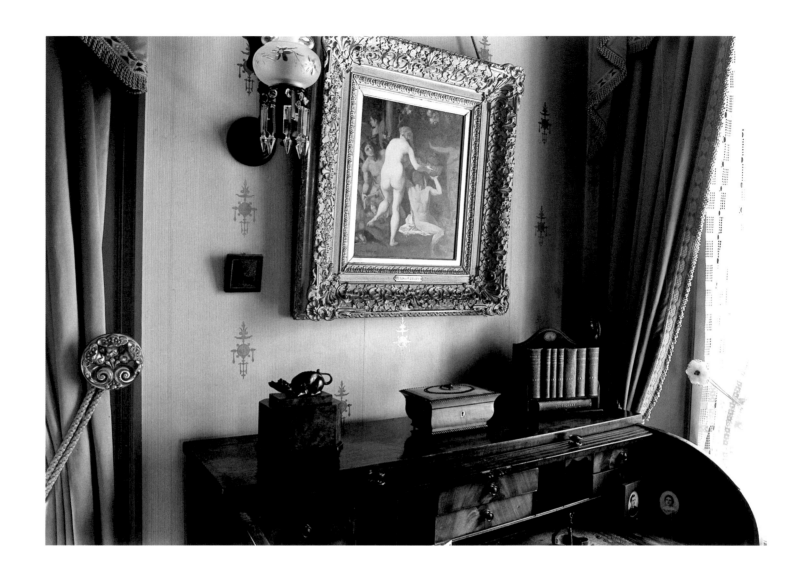

Arranged by Mr. & Mrs. Alfred Atmore Pope or Their Daughter Theodate
(Puvis de Chavannes Over Sheraton Rolltop Desk), 1983

black and white photograph with text on mat
(image) 18$^{1/2}$ x 22"
(mat) 28 x 32"

Peace by Pierre Puvis de Chavannes over Sheraton rolltop desk at
the Hillstead Museum, Farmington, Connecticut.

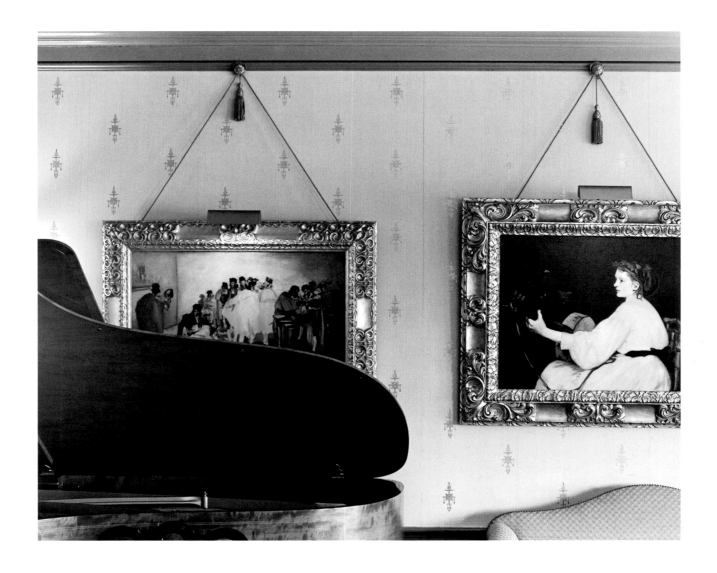

Arranged by Mr. & Mrs. Alfred Atmore Pope or
Their Daughter Theodate (Manet),1983

black and white photograph with text on mat
(image) 18 1/2 x 22"
(mat) 28 x 32"

Theodate Pope Riddle was the last resident of Hillstead. In her will
she directed the executors to "maintain (it) the same forever as a
museum in which the past would remain untouched and inviolate."

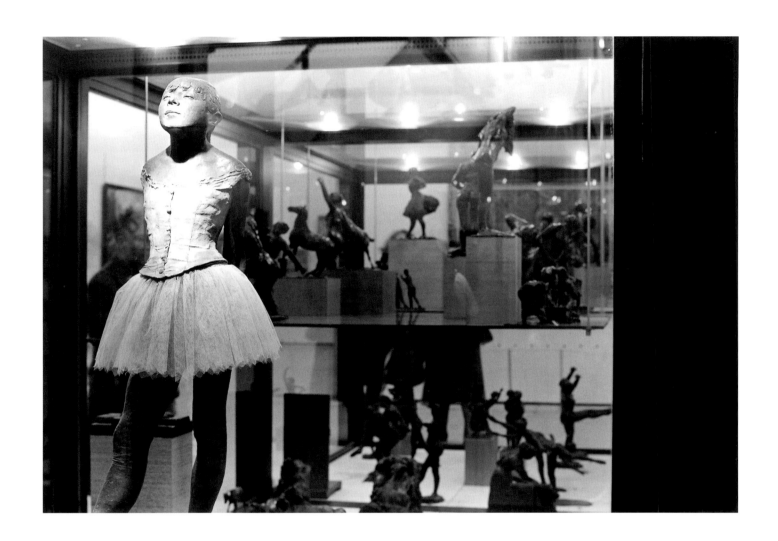

Glass Cage, 1991/93

two black and white photographs with text on mat
left panel (image) 15 x 21¹/⁴"
(mat) 27 x 31"

right panel (image) 12 x 15"
(mat) 27¹/⁴ x 24¹/⁴"

Paris

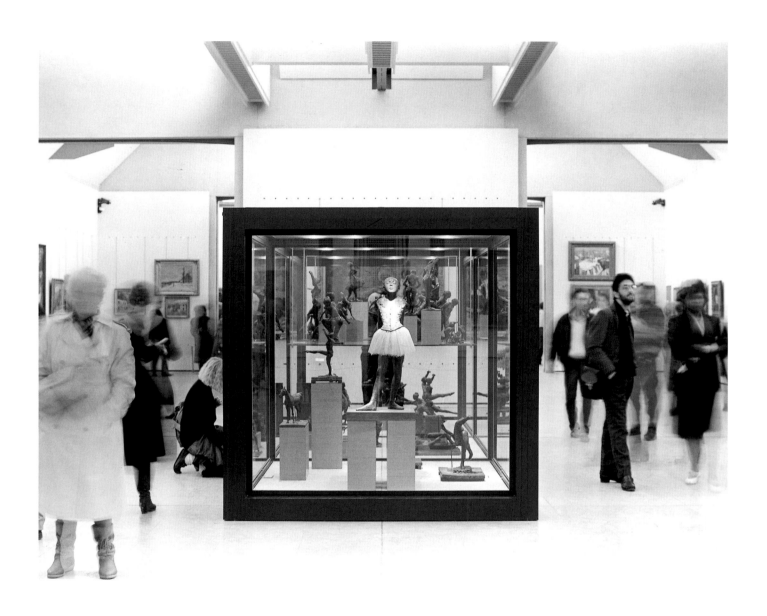

The following year her glass "cage" remained empty for the first
two weeks of the exhibition. When finally exposed, she was likened
by one critic to an "expelled foetus" which if smaller "...one would
be tempted to pickle in a jar of alcohol."

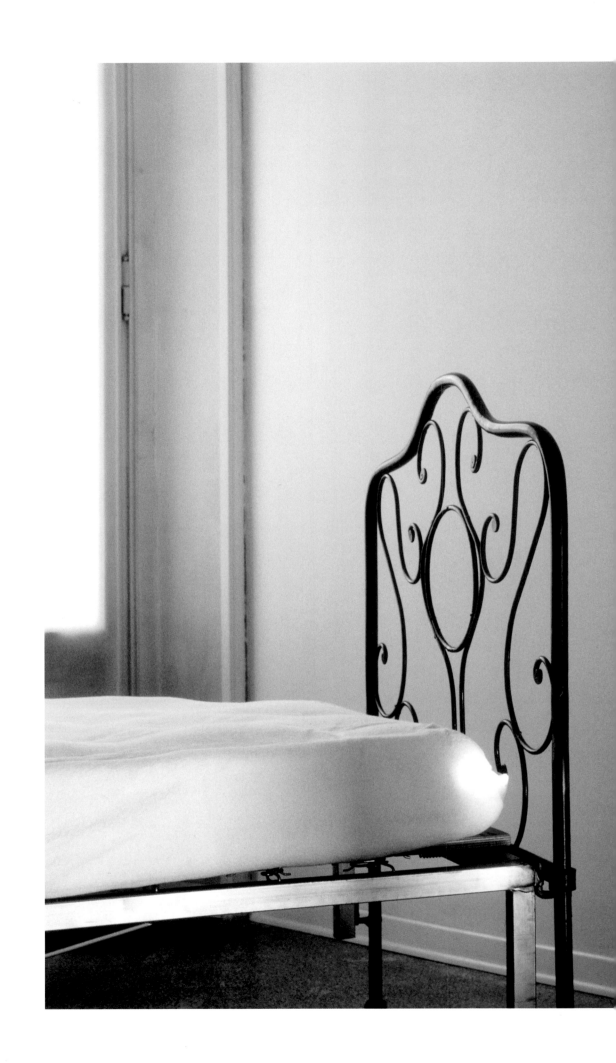

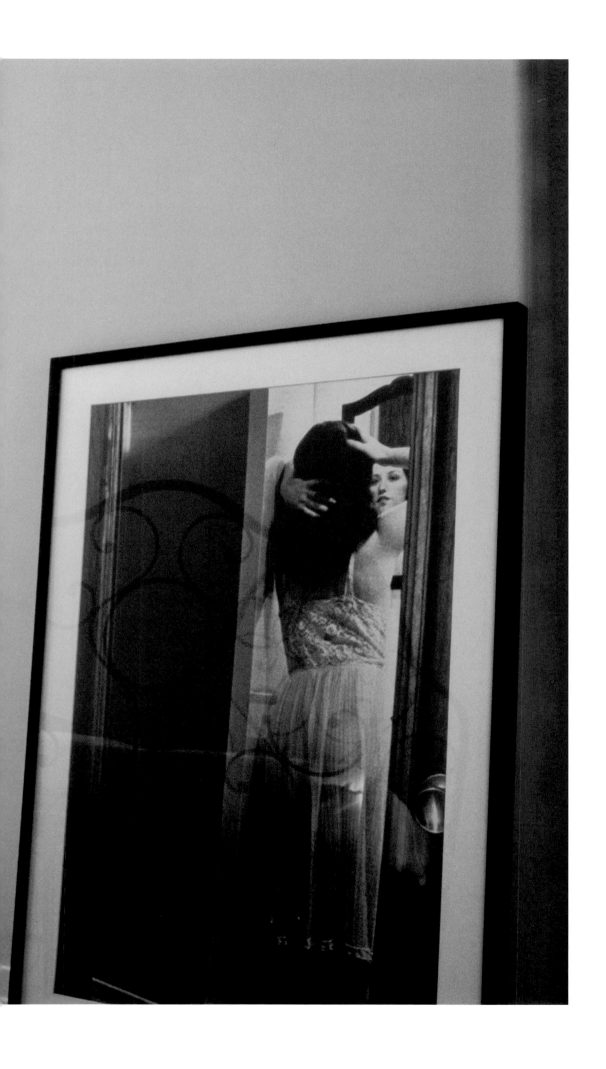

Next page
A Good Room To Sleep In, 1994
Storage, 1984
cibachrome, 18⁷⁄₈ x 23¹⁄₂"
black and white photograph, 15¹⁄₂ x 23"

Nipple, 1984/93

two black and white photographs with text on mat
left panel (image) 14³/⁴ x 21¹/²"
(mat) 28 x 32"

righ panel (image) 8 x 14¹/²"
(mat) 28 x 25"

"Does He Get Enough Attention"

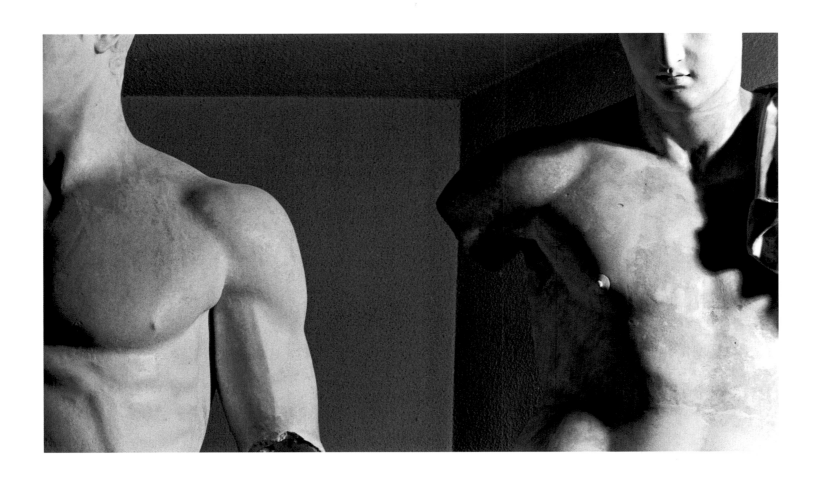

Nipple

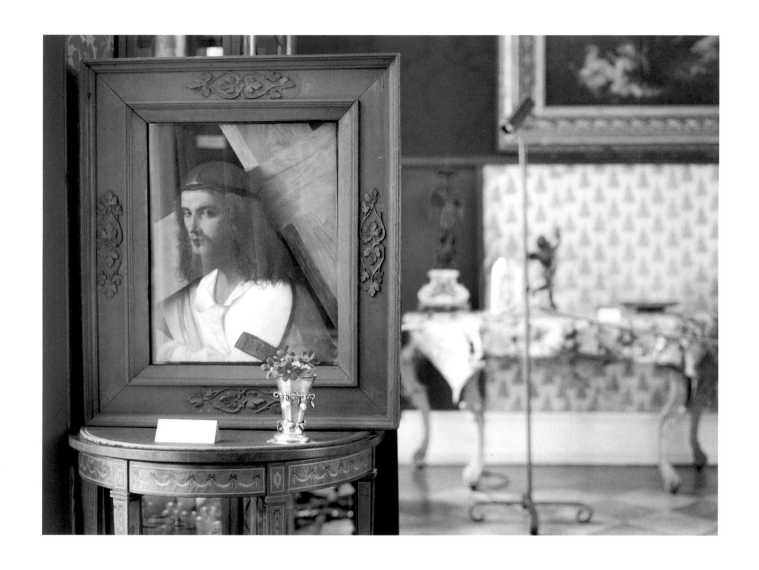

Who Chooses The Details?, 1990

cibachrome with text on mat
(image) 17⅞ x 23⅜"
(mat) 28 x 32"

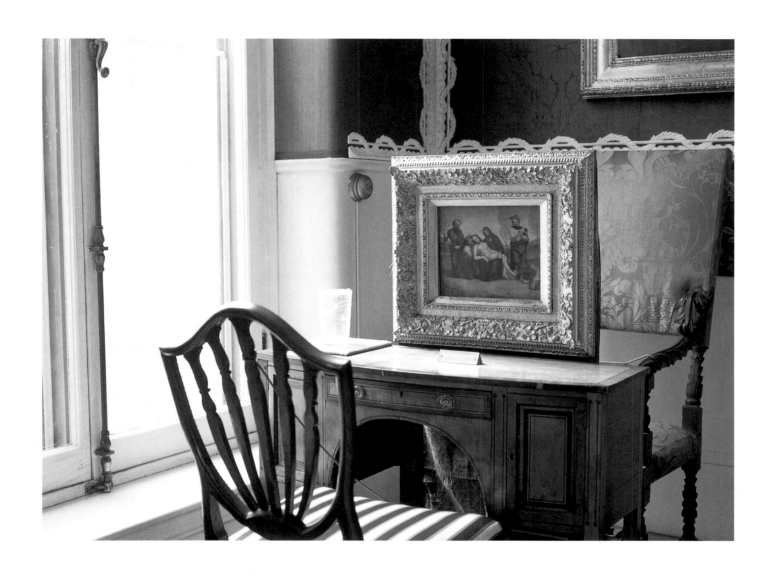

Does It Mater Who Owns It?, 1990

cibachrome with text on mat
(image) 17 x 23 $^{1/2}$"
(mat) 28 x 32"

Pictures That May or May Not Go Together, 1997/1998
cibachrome, 24 x 30"

Produced in 1988, Purchased in 1989,
Produced in 1989, Purchased in 1993, 1995

cibachrome, 45 x 58¹ᐟ²"

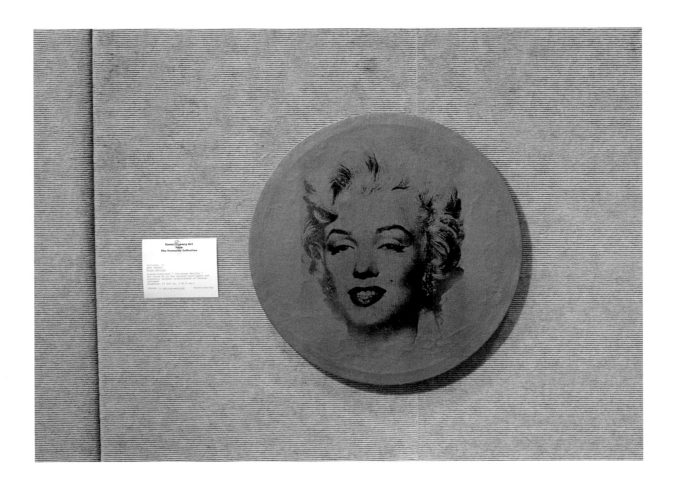

Does Andy Warhol Make You Cry, 1988

cibachrome, plexiglass wall label
(image) 27¹/⁴ x 39"

an identical image exists with the title
"Does Marilyn Monroe Make You Cry"

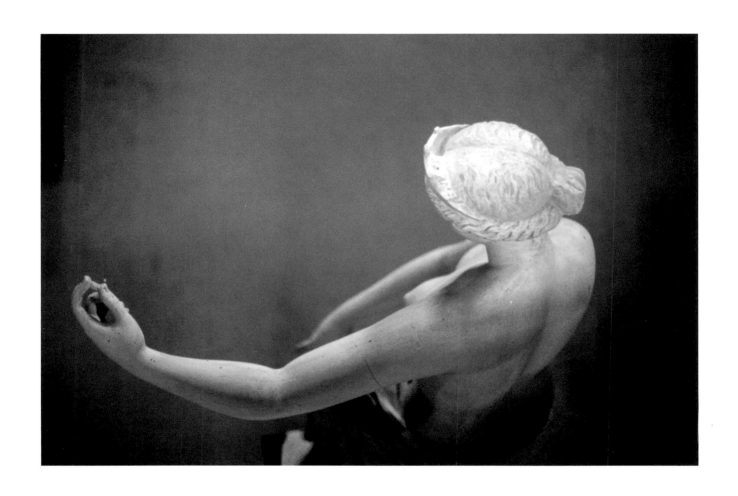

Woman (Statue) from Above, 1985
cibachrome, 24¹/² x 36¹/²"

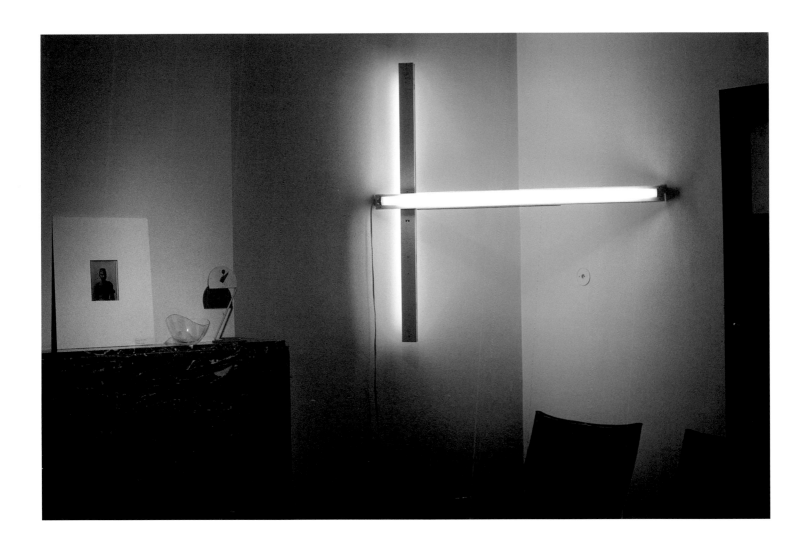

Brussels: Aqua Arec, 1988
cibachrome, 26$^{1/2}$ x 38$^{1/4}$"

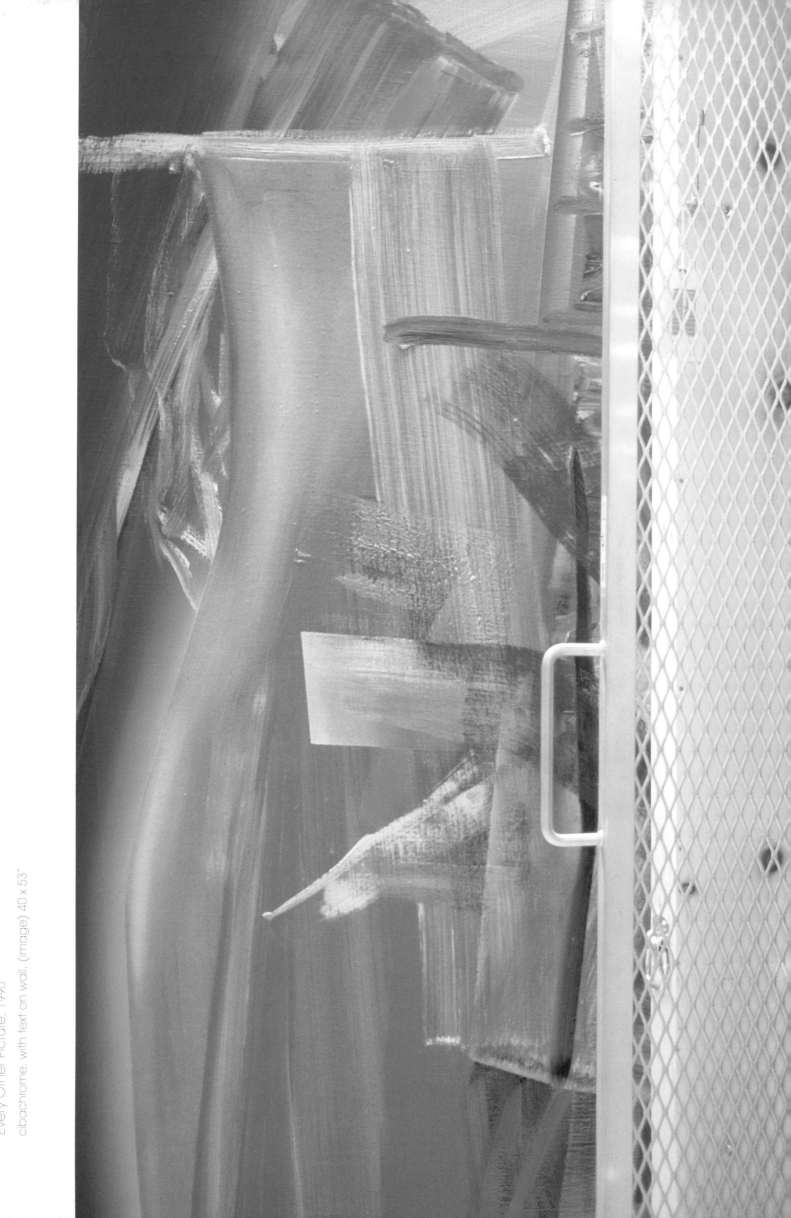

Every Other Picture, 1990

cibachrome, with text on wall, (image) 40 x 53"

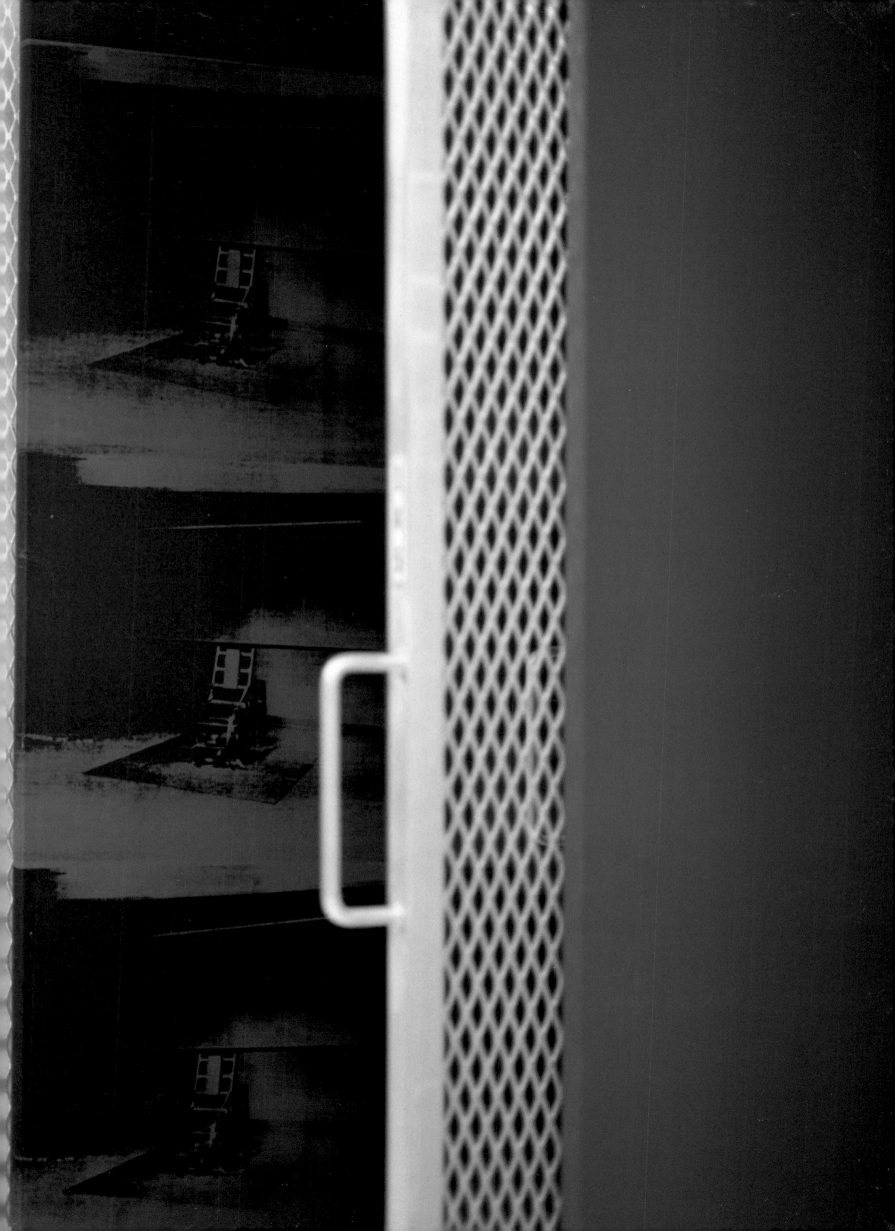

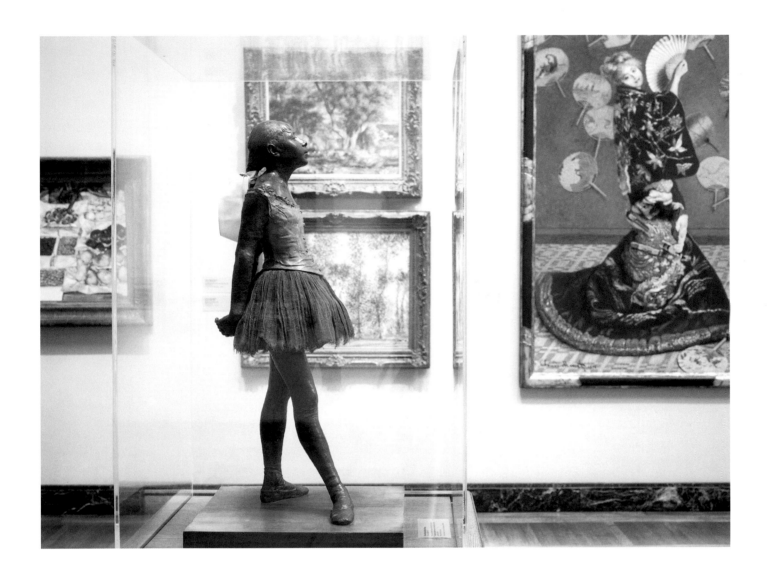

Is She Ours?, 1990
cibachrome, with text on wall, (image) 40 x 53"

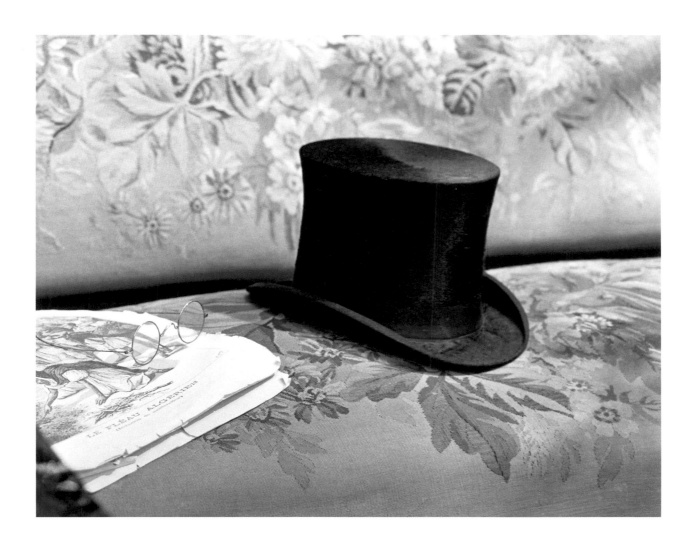

Combien Pour Ce Chapeau?, 1987
three black and white photographs, text on mats, 20 x 24" each

Combien Pour Ce Chapeau?

An Old Hat

SAPPHO AND PATRIARCH, 1984
Is it the work, the location, or the stereotype that is the institution?

Sappho and Patriarch, 1984
cibcchrome, 27$^{1/2}$ x 39$^{3/4}$"

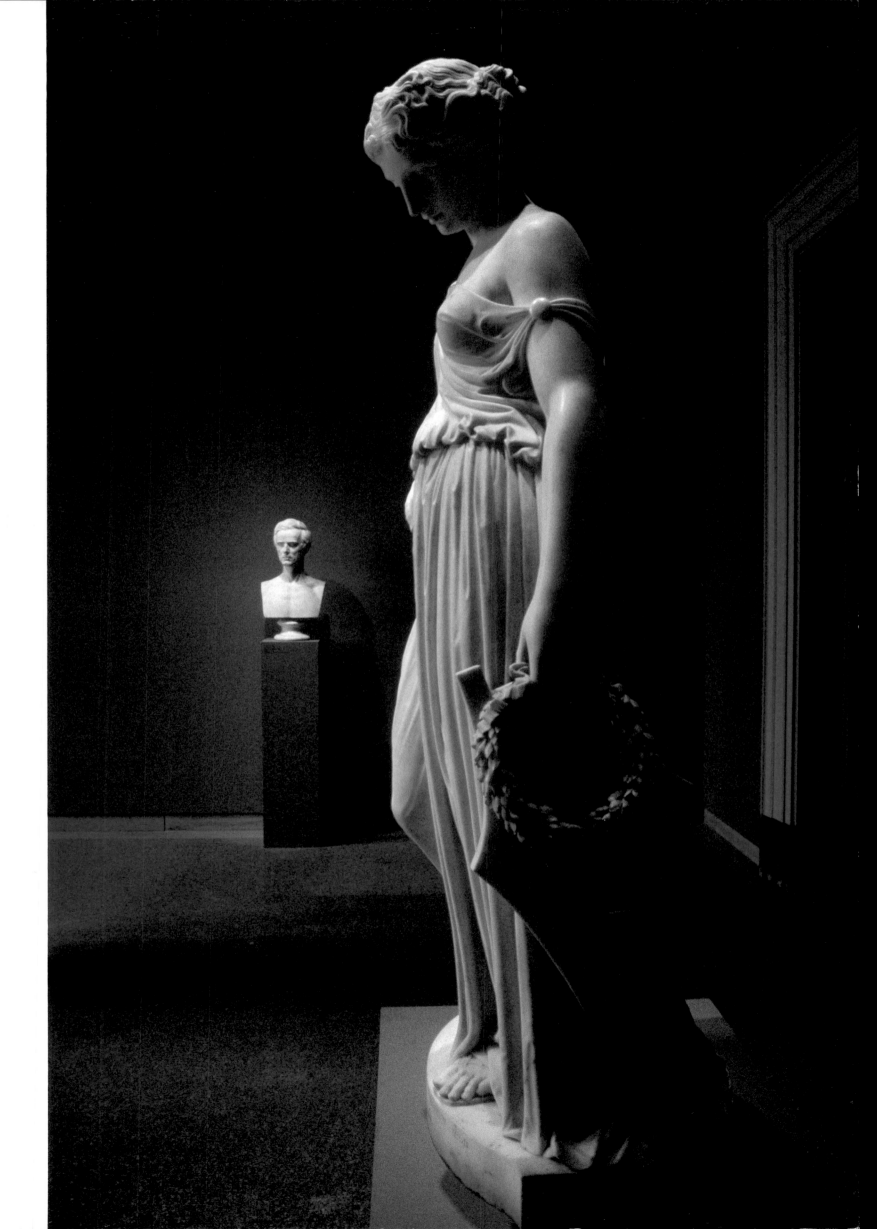

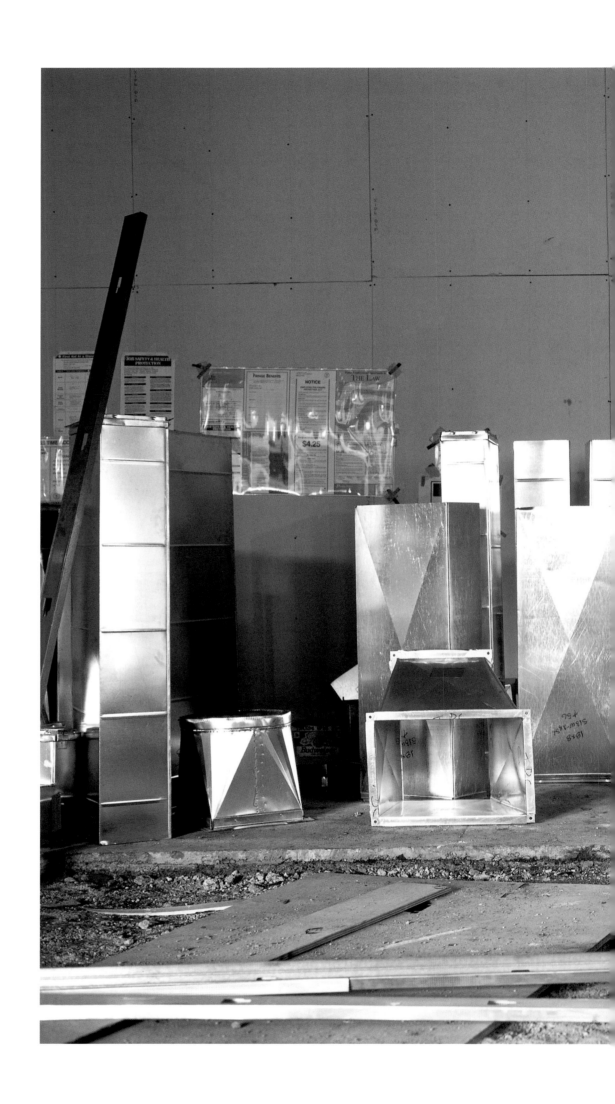

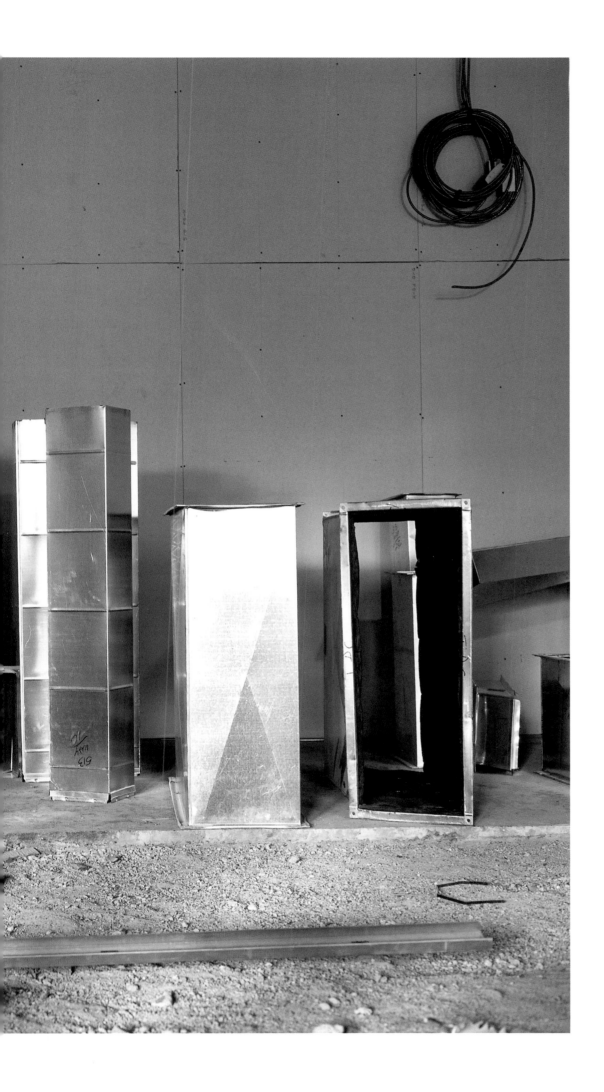

HVAC, 1996

cibachrome, 61³/⁴ x 47⁷/⁸"

Red (Rectangle), 1996

cibachrome, 48 x 62 1/4"

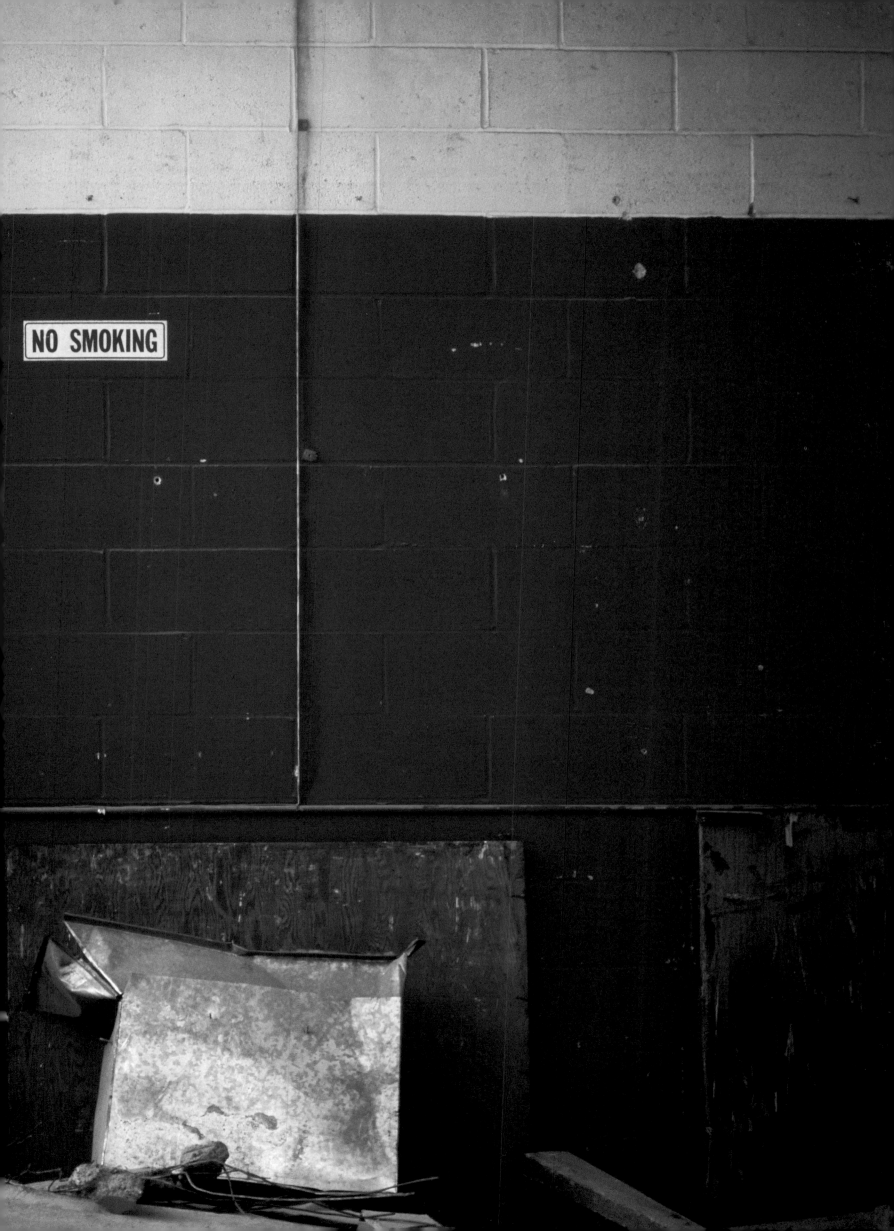

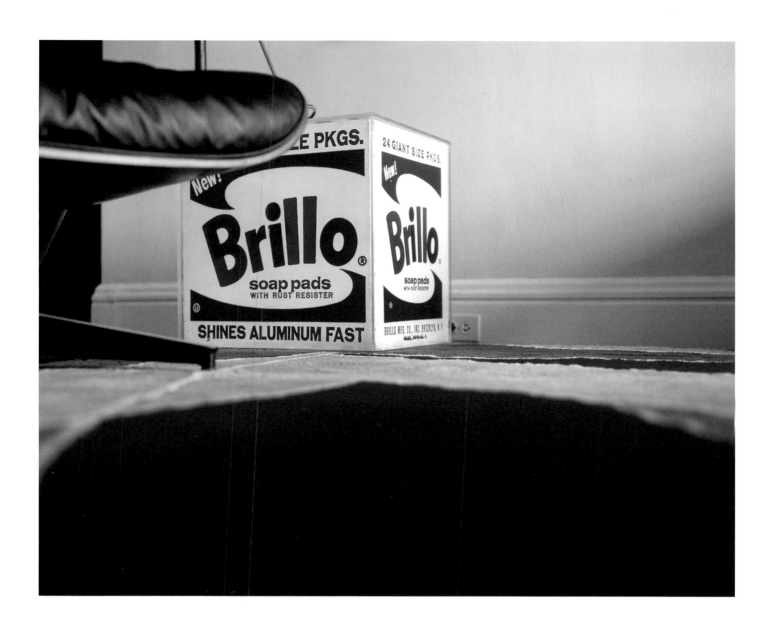

I-O, 1993/98
cibachrome, 19⁵/₁₆ x 23³/₈"

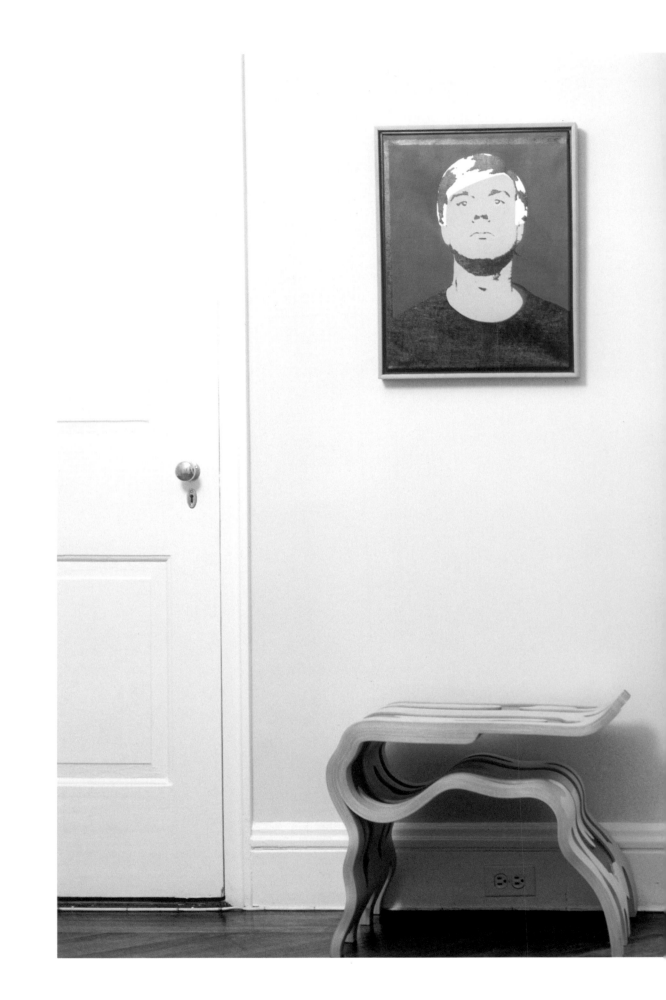

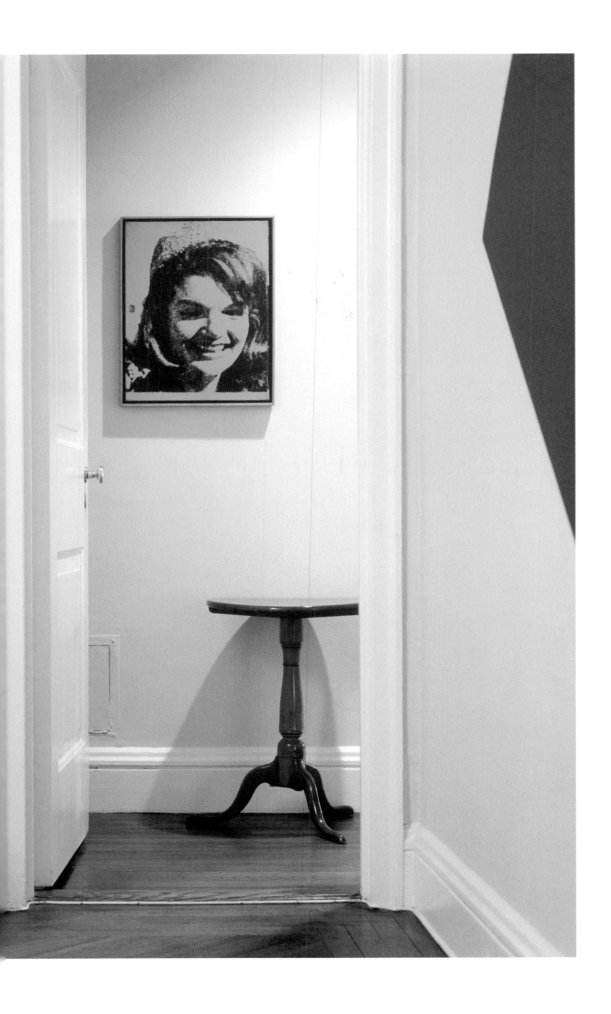

What Goes on Here, 1990
cibachrome, 40 x 54"

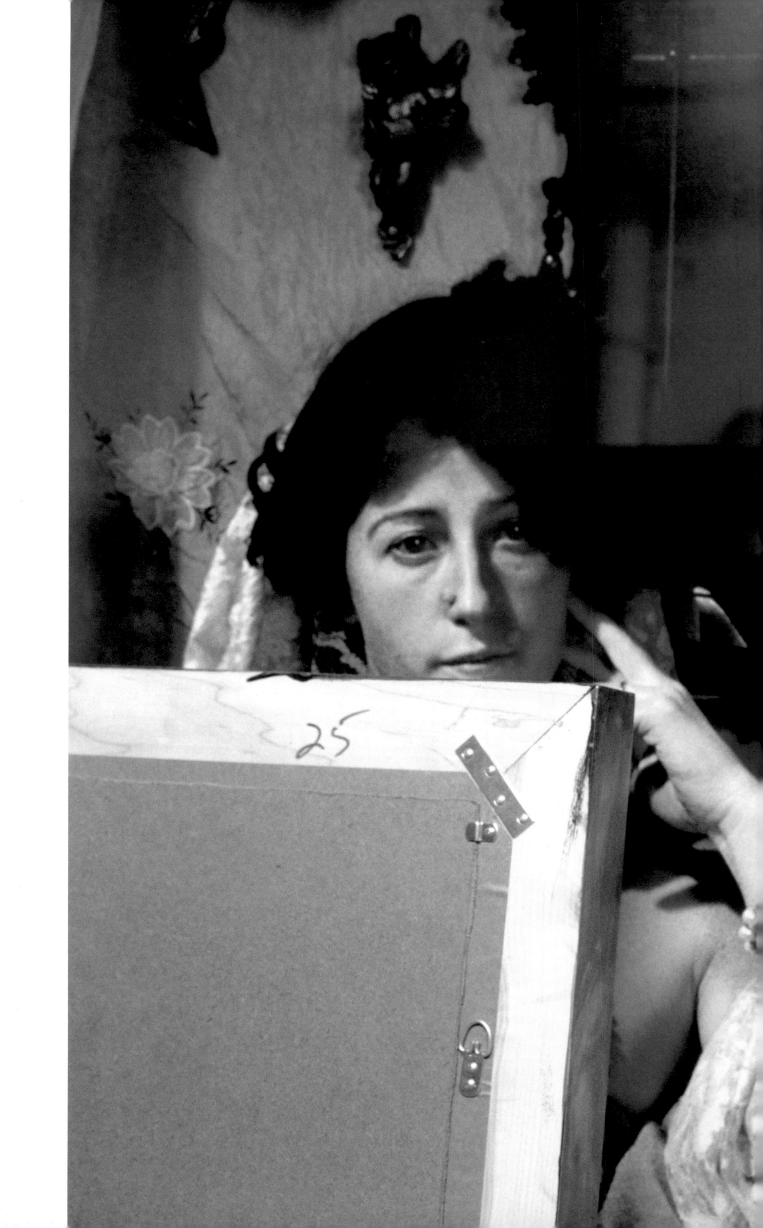

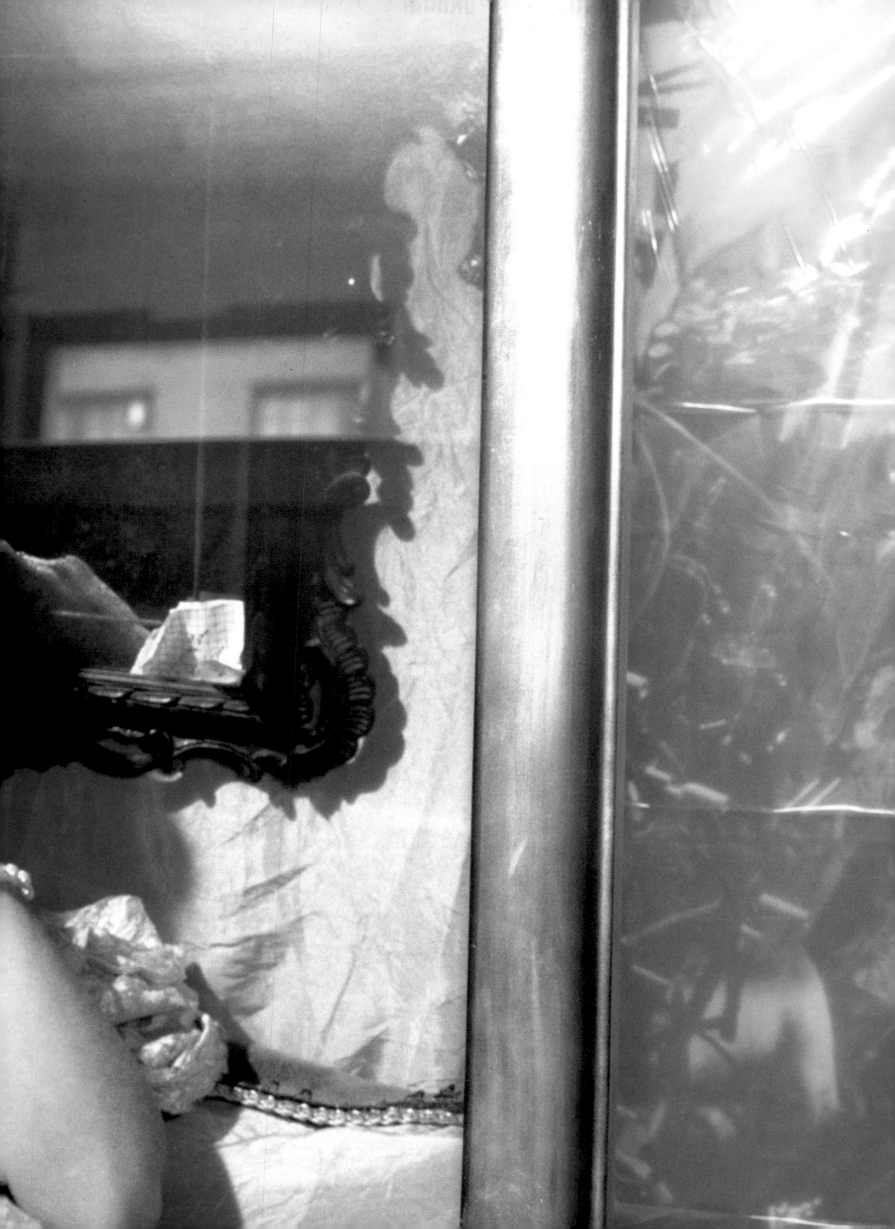

EXH

Exhibition, 1987

text on glasses, shelves, painted wall, transfer type
two cibachromes, 90 x 260"

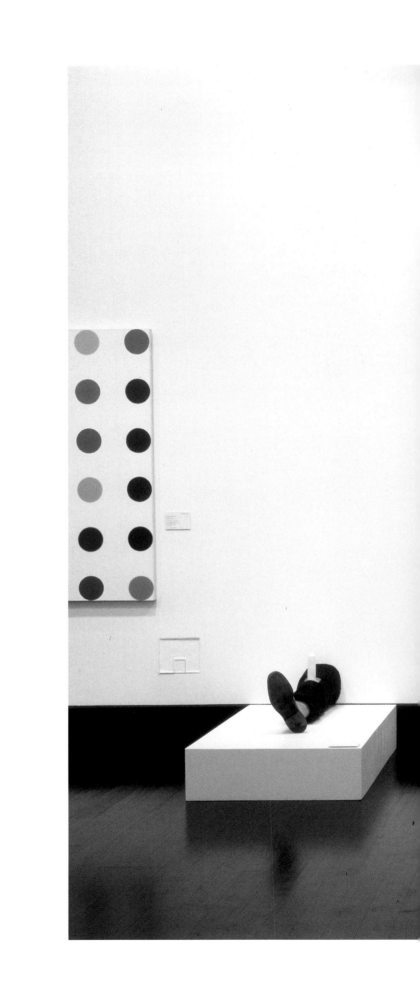

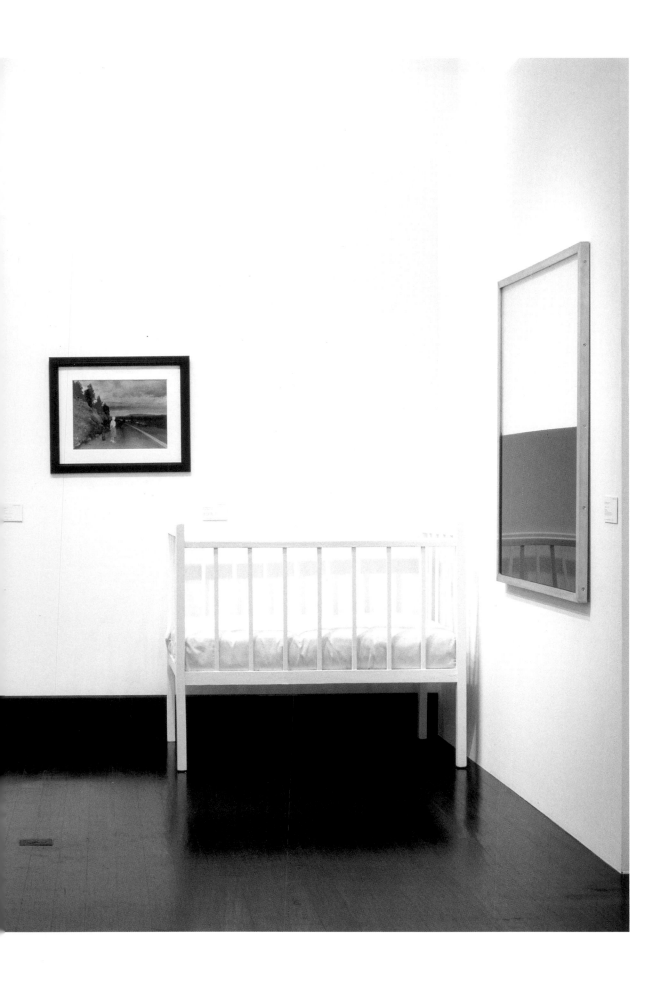

Unsentimental, 1999/2000

cibachrome, 47¹⁄₂" x 57"

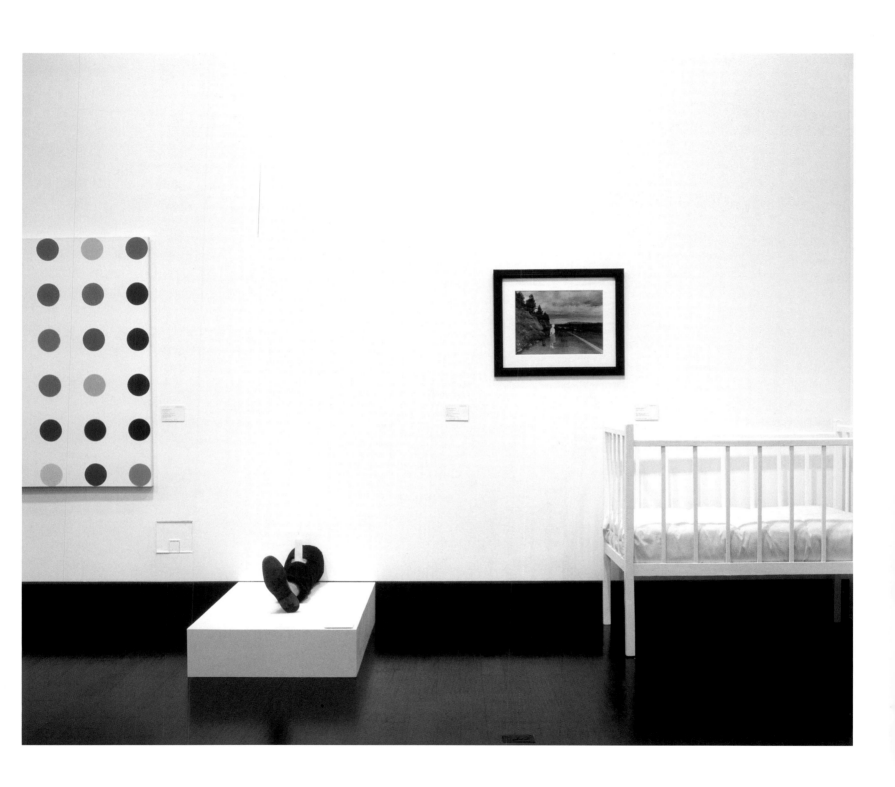

Sentimental, 1999/2000
cibachrome, 41 x 49¹/⁴"

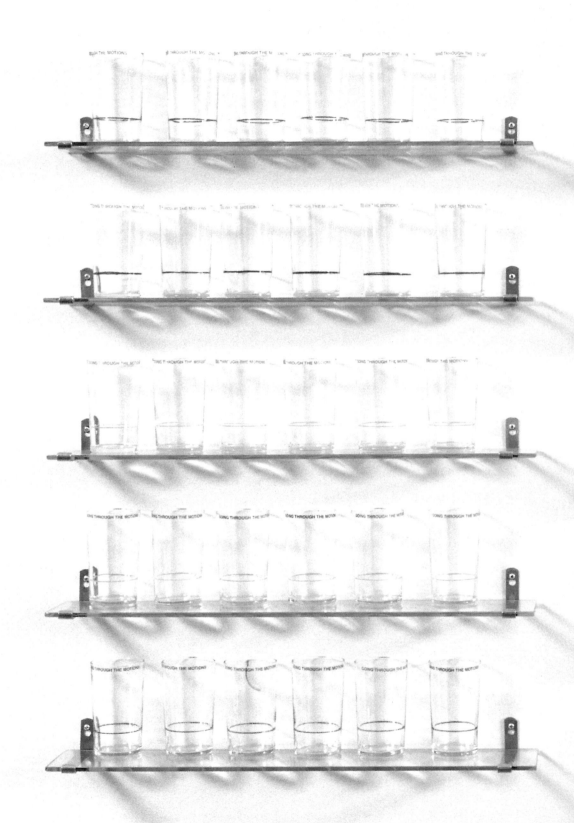

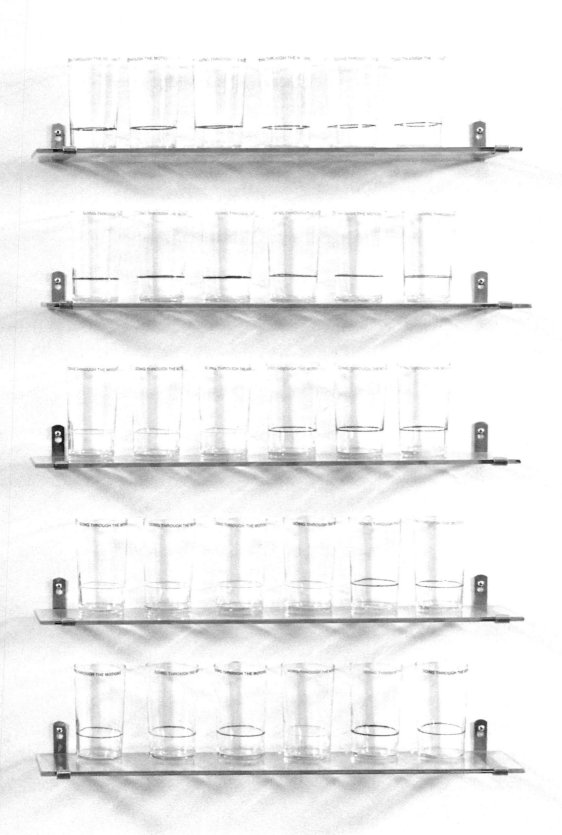

Going Through the Motions, 1986
glasses with text, 4½ x 2½" each

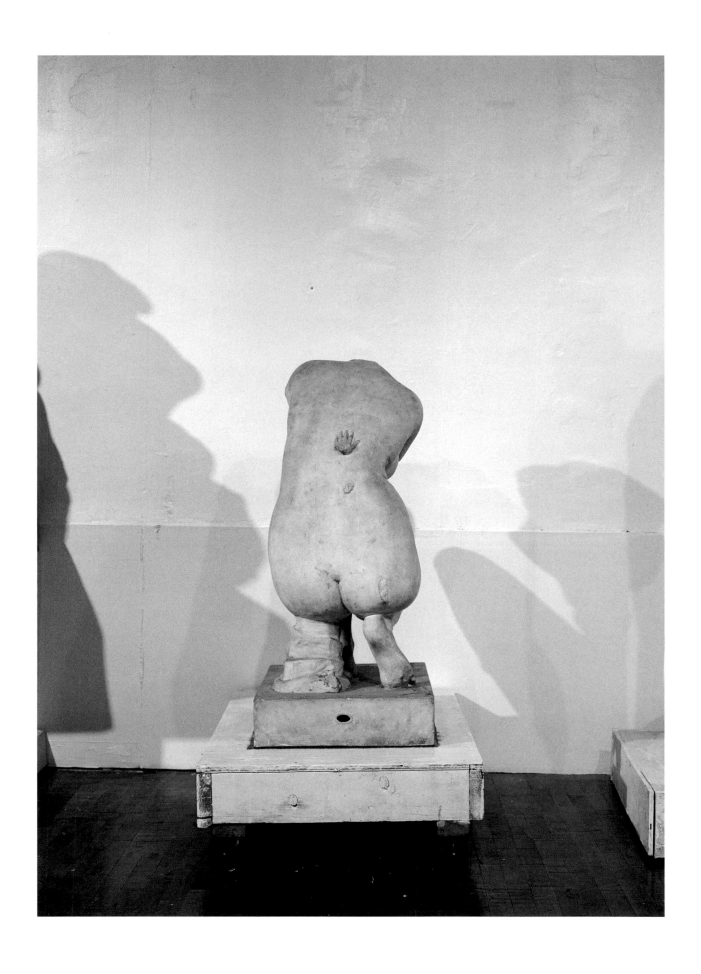

Hand On Her Back, 1997/98

cibachrome, 60¹/² x 43¹/²"

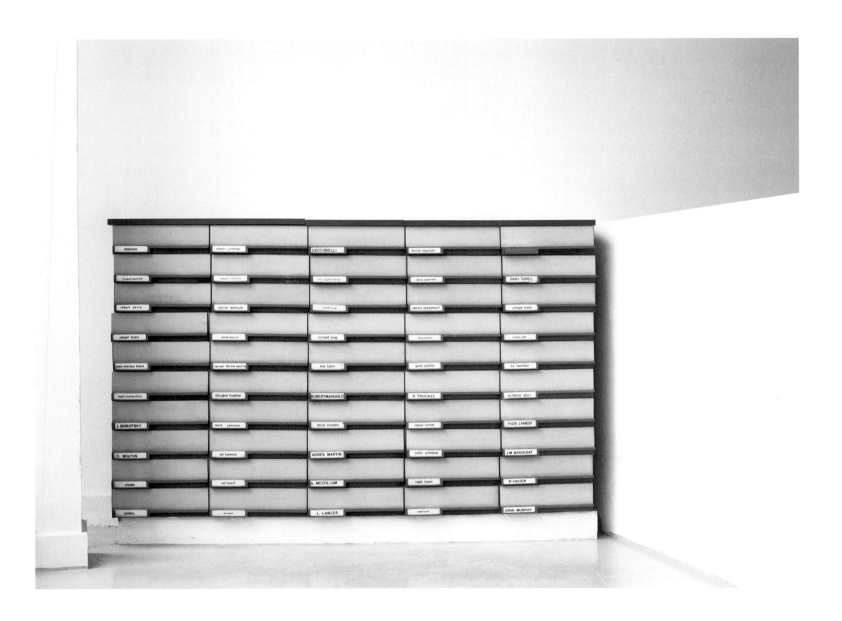

Les Coordonnées, 1988
cibachrome, 26 x 38³/⁴"

Poached Leeks with Pink Peppercorn
Mayonnaise

Rabbit with Pine Nuts and Currants
Lemon Rice
Sorrel Flan

Rhubarb Sorbet

Dolcetto d'Alba

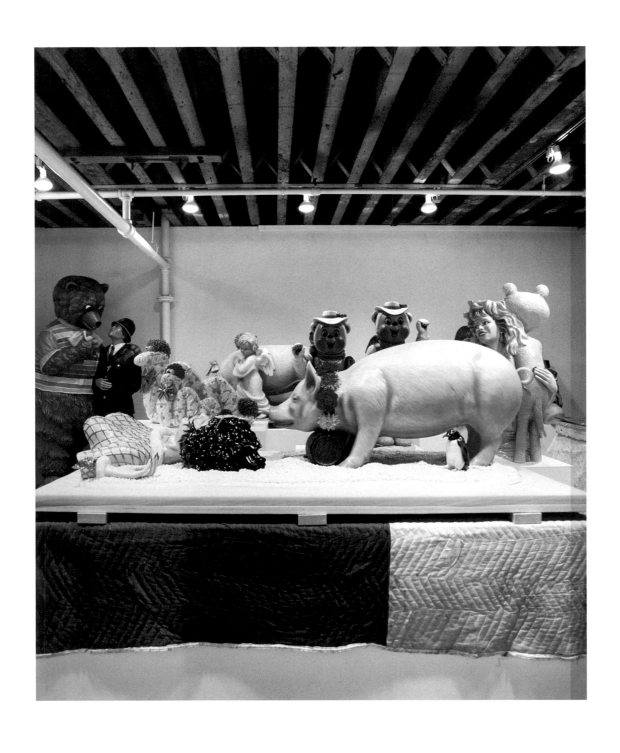

Between Reagan and Bush, 1989
cibachrome, painted wall, text, 22 x 43"

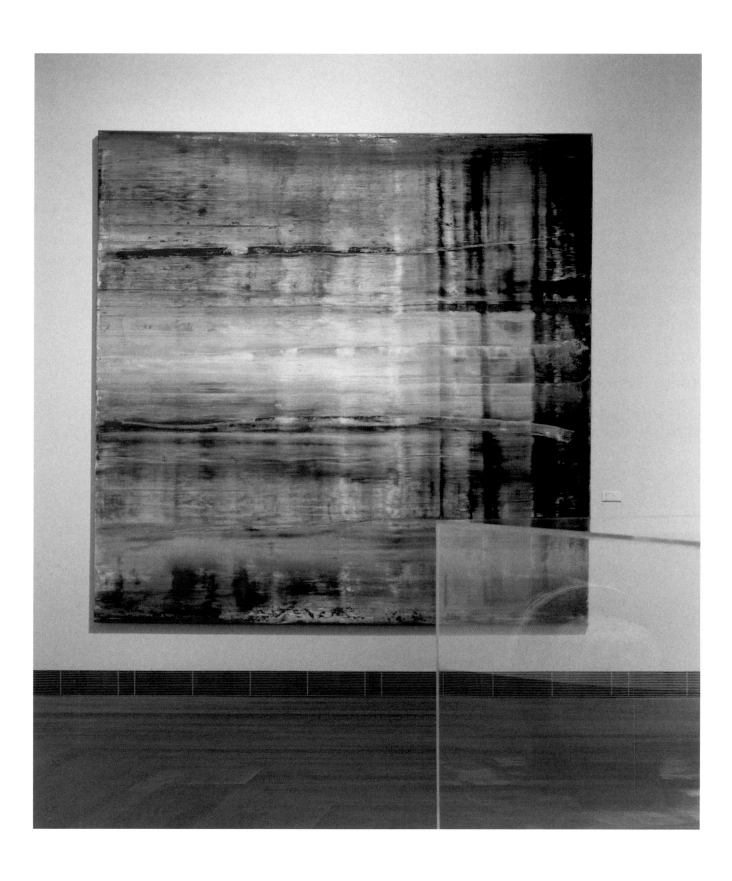

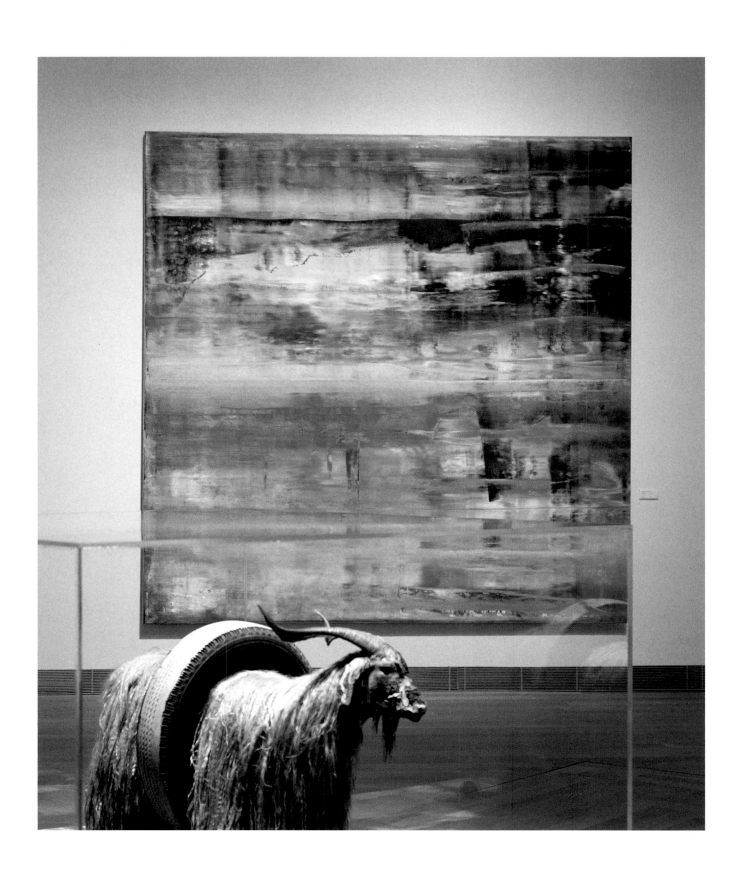

Painting and Sculpture, 1998/99

two cibachromes, 47³/⁴ x 41″ each

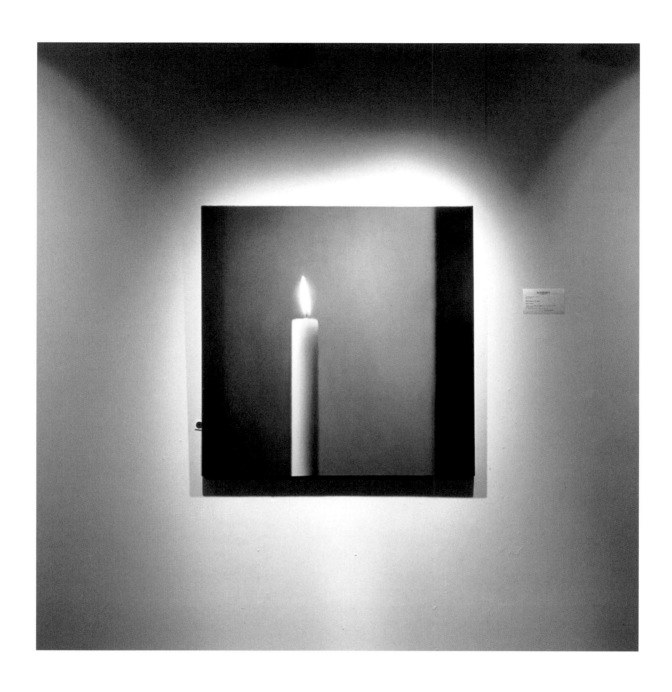

What Else Could I Do, 1994

cibachrome, 24 x 24"

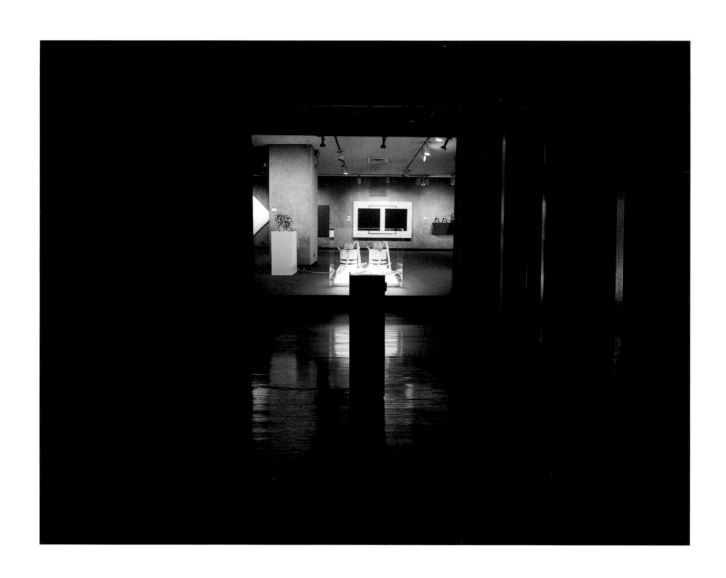

External Stimulation, 1994

a different image on alternating nights
7 minutes every 10 minutes, 6-10 PM

Untitled (Dreams), 1993

crystal paperweight, cibachrome and felt, 2 x 3$^{1/2}$"

Edward Ruscha
Dreams #1, 1987
Acrylic on paper
17 x 46"

To 420 from artists 3/14/89
To Thaddeus Ropac, Salzburg "Freud" 5/2/89
To Castelli Gallery, 578 Broadway for group drawing exhibit 9/26/89
Purchased by Leo Castelli 9/28/89
To LC apartment 1/22/90

Roy Lichtenstein
Ball of Twine, 1963
Pencil and tusche on paper
15 x 12"

Gift to Leo Castelli from the artist 6/64
To LC apartment 6/24/64
To Philadelphia Museum of Art Exhibit (6/63-9/65)
To LC apartment 10/5/65
To Pasadena Museum (first Museum Retrospective 4/18-5/28/67), travels
To Walker Art Center (6/23-7/30/67)
To Stedelijk Museum, Amsterdam 10/5/67
To LC apartment 6/2/68
To Guggenheim Museum (first museum retrospective in New York), travels
To Nelson Gallery of Art, Kansas City; Seattle Art Museum;
Columbus Gallery of Fine Arts; and Museum of Contemporary Art, Chicago
To LC apartment 12/9/70
To Centre National d'Art Contemporain, Paris, retrospective drawing exhibition,
"Dessins sans bande," travels to Nationalgalerie,
Staatliche Museen Preussischer Kulturbesitz, Berlin
To Ohio State University 10/21/75
To Metropolitan Museum & Arts Center, Miami 2/17/76
To LC apartment 5/8/79
To MOMA "In Honor of Toiny Castelli" Drawings from the Toiny, Leo and
Jean-Christophe Castelli Collection (4/6-7/17/88)
To LC apartment 1/24/89
To Guild Hall, East Hampton "A View from the Sixties: Selections from the
Leo Castelli Collection and the Michael and Ileana Sonnabend Collection" (8/10-9/22/91)
To LC apartment 10/21/91

This will mean more to some of you than others

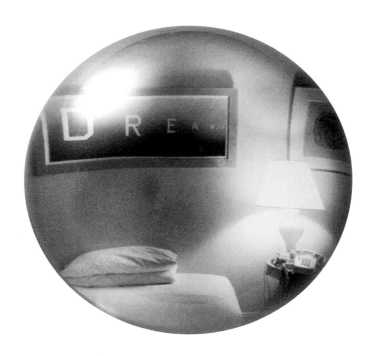

Untitled (Stella), 1989

crystal paperweight, cibachrome and felt, 2 x 3$^{1/2}$"

Untitled (Parrot), 1982/83

crystal paperweight, cibachrome and felt, 2 x 3$^{1/2}$"

Portrait

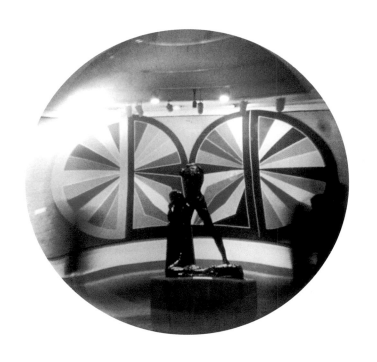

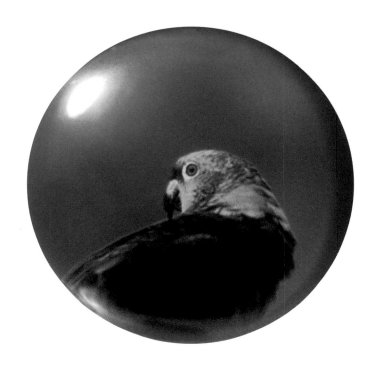

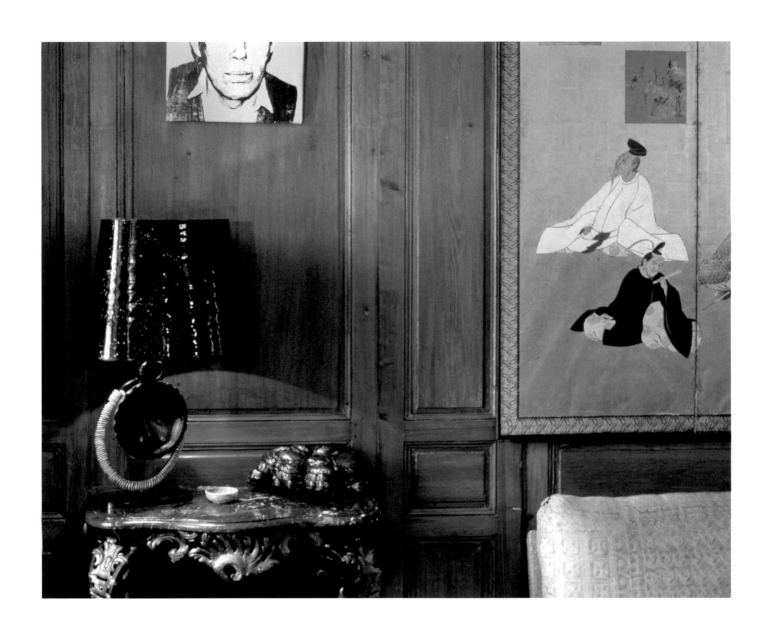

It Could Be Elvis, 1994

cibachrome, 29$^{1/4}$ x 35$^{1/8}$"

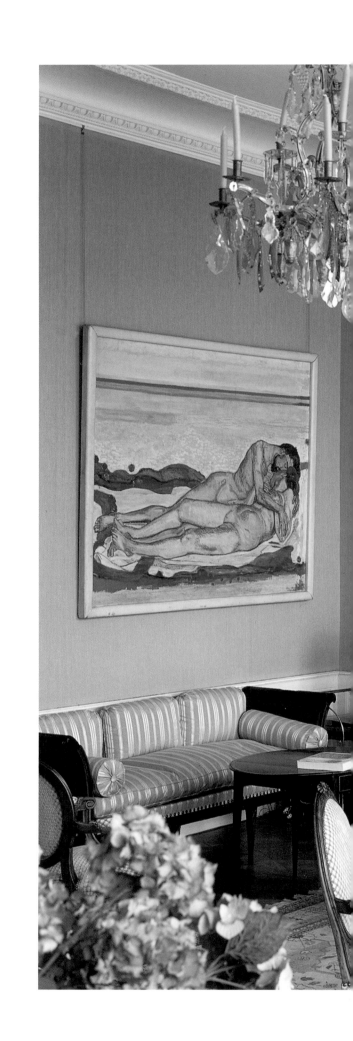

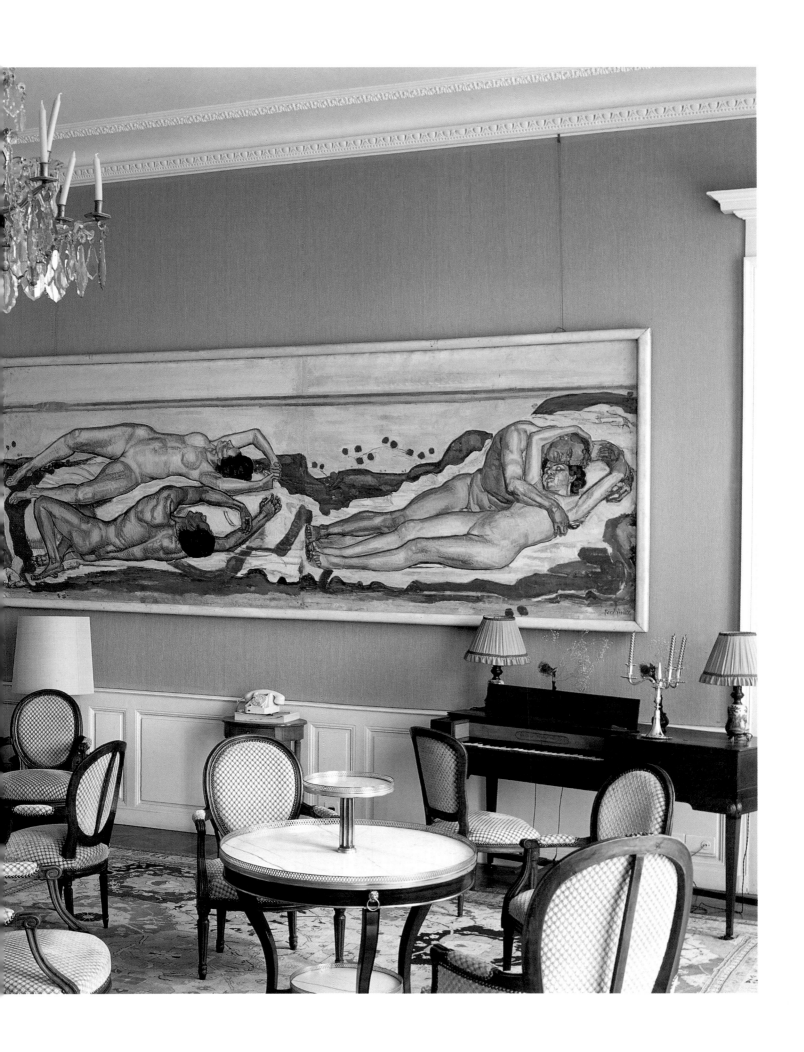

Salon Hodler, 1992/1993
cibachrome, 58¹/² x 49¹/⁴"

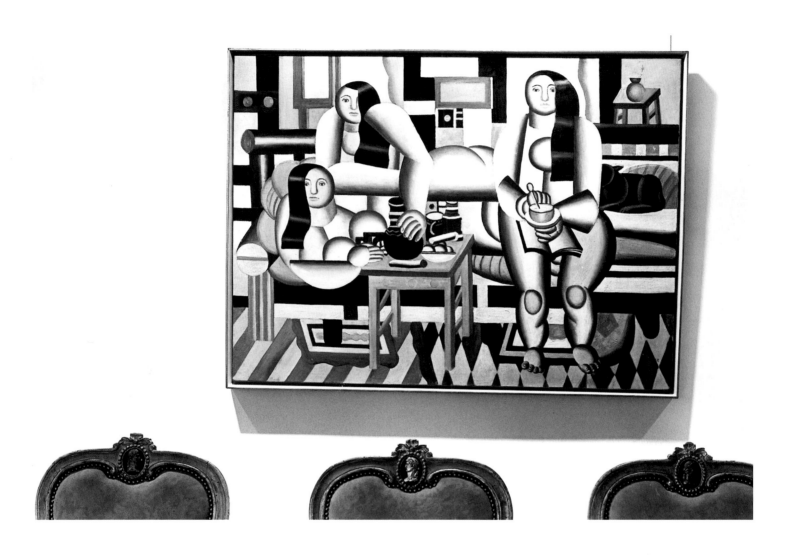

Three Women Three Chairs,
Arranged by Mr. & Mrs. Burton Tremaine Sr., New York, 1984

black and white photograph, mat with text
(image) 18 x 23"
(mat) $28^{1/8}$ x $31^{1/8}$"

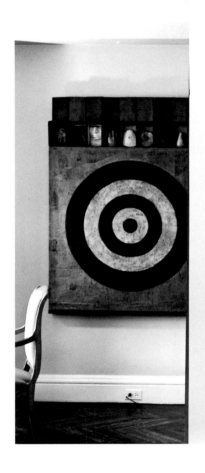

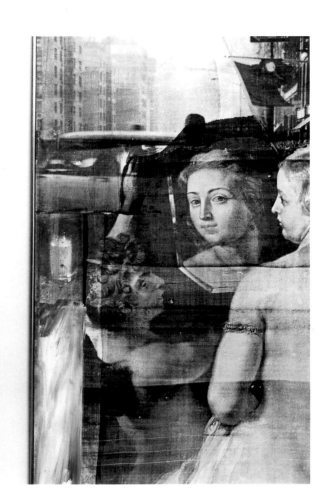

From Here to There, 1990

black and white photograph with text on mat
(image) 15$^{1/2}$ x 23"
(mat) 29$^{1/4}$ x 33"

Data shows that women are higher rates of mental disorders in several important categories. Single, divorced, and widowed women have fewer mental problems than men in the same categories.

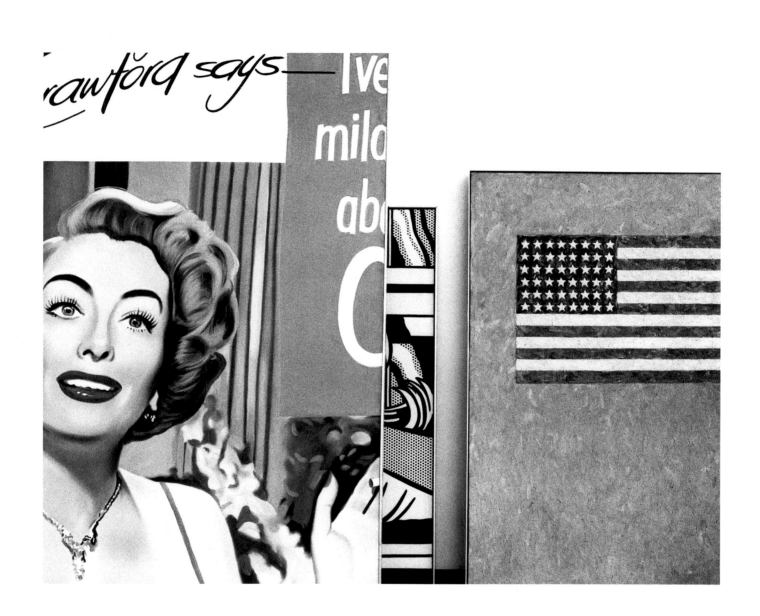

Two Pictures, 1992
two black and white photographs with text on mat
28 x 32" each

"Did you get what you deserve?
More than you deserve? Less?"

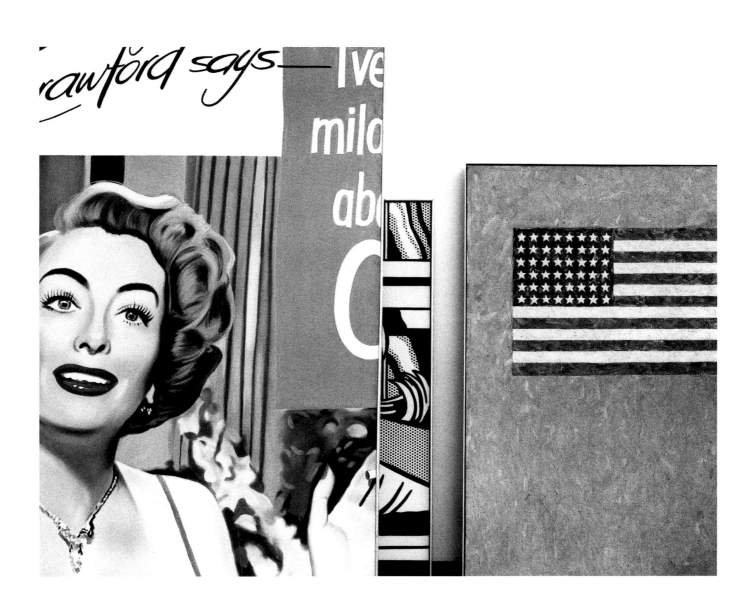

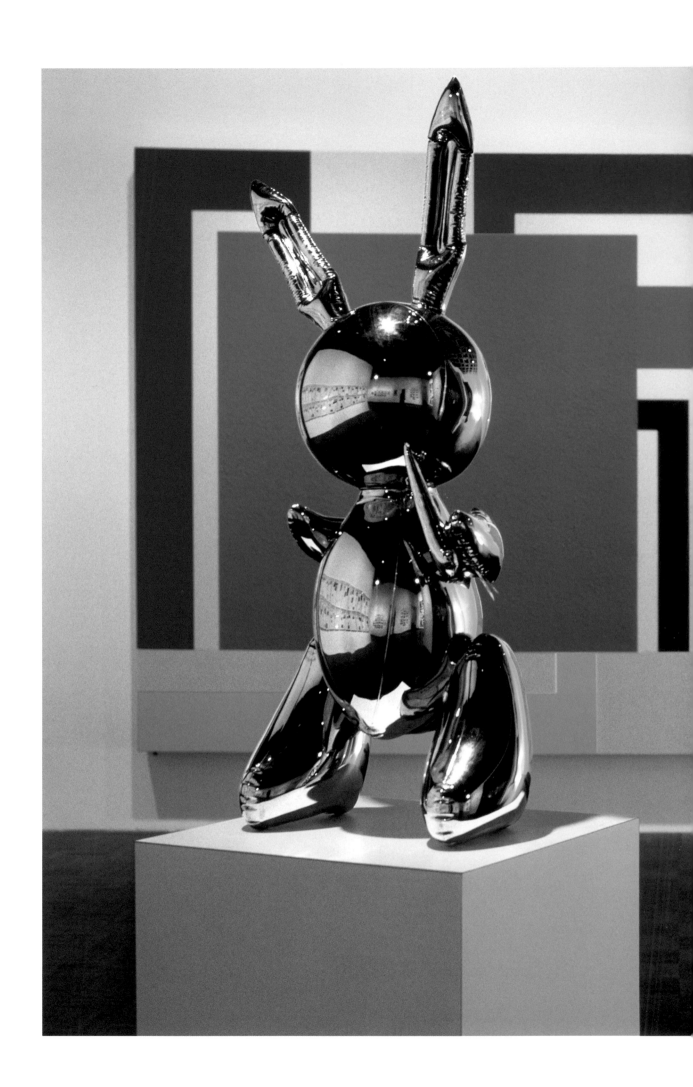

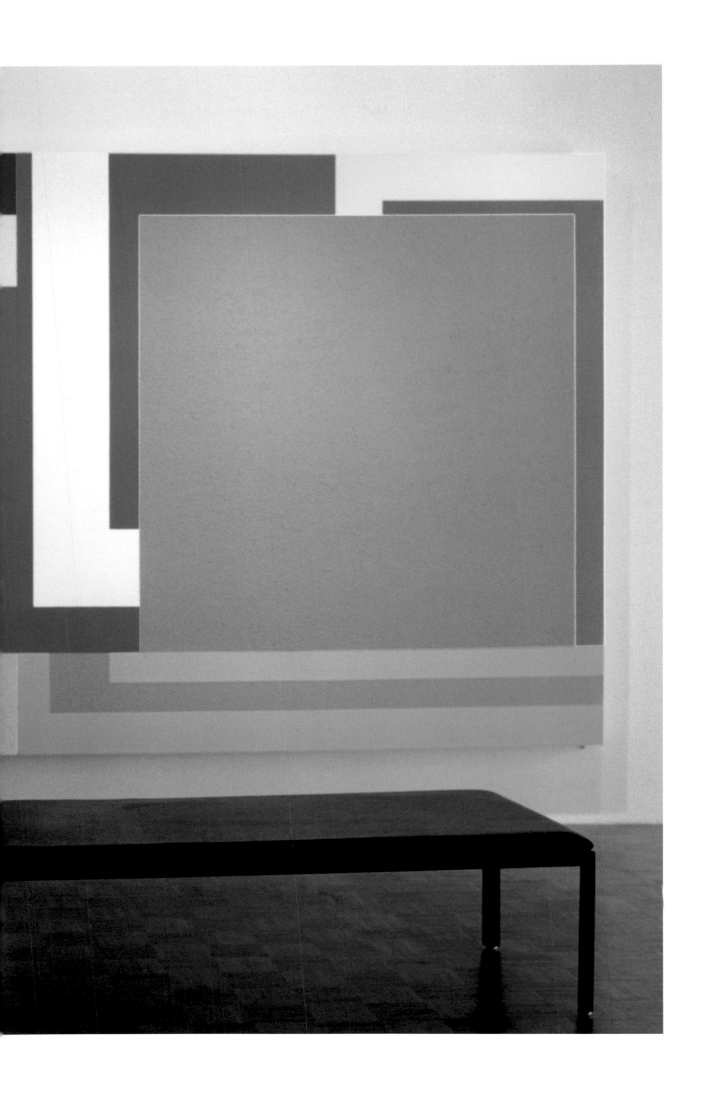

(Bunny) Sculpture and Painting, 1999

cibachrome, 47$^{1/2}$ x 66˝

Given by the Widow, 1993

cibachrome, 25³/⁴ x 32³/⁴"

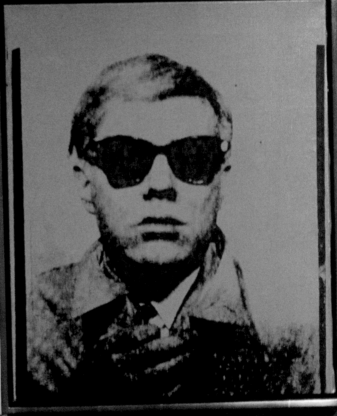

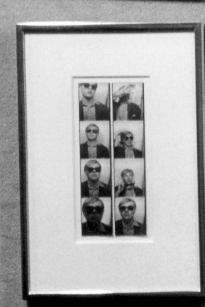

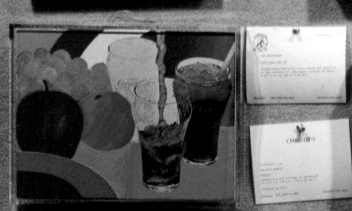

HANDLE WITH CARE
GLASS
THANK YOU

HANDLE WITH CARE
GLASS
THANK YOU

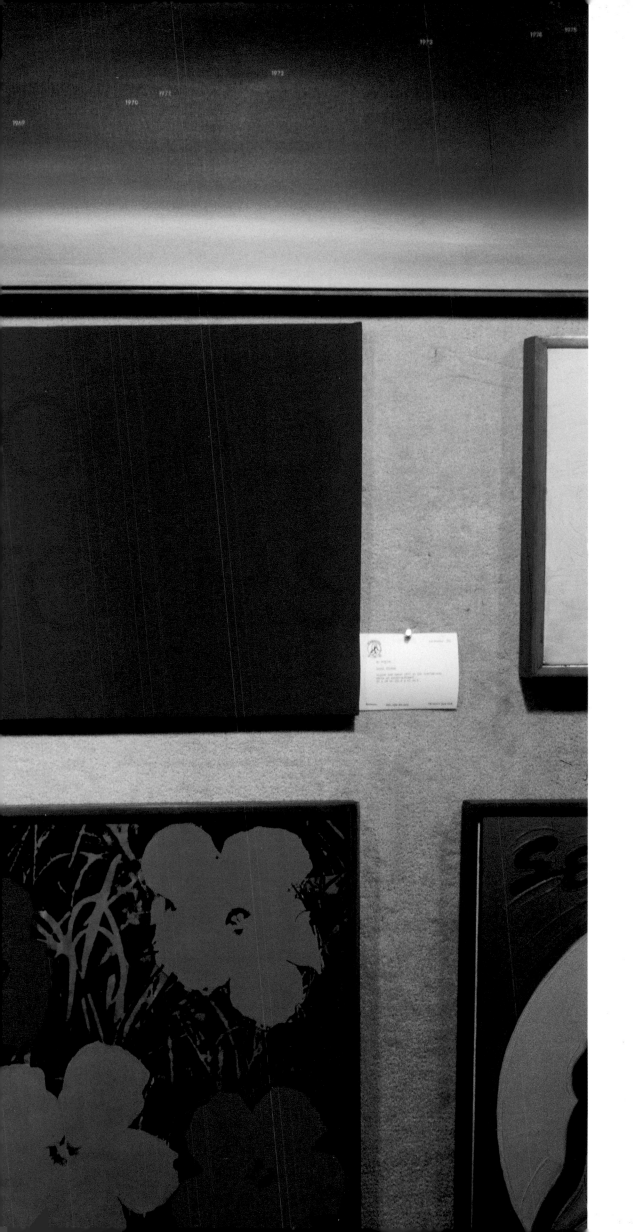

Glass and Local Storms, 1990
cibachrome, 41 x 52"

Something About Time And Space But I'm
Not Sure What It is (One) Natural, 1998

cibachrome, 24 x 29¹/²"

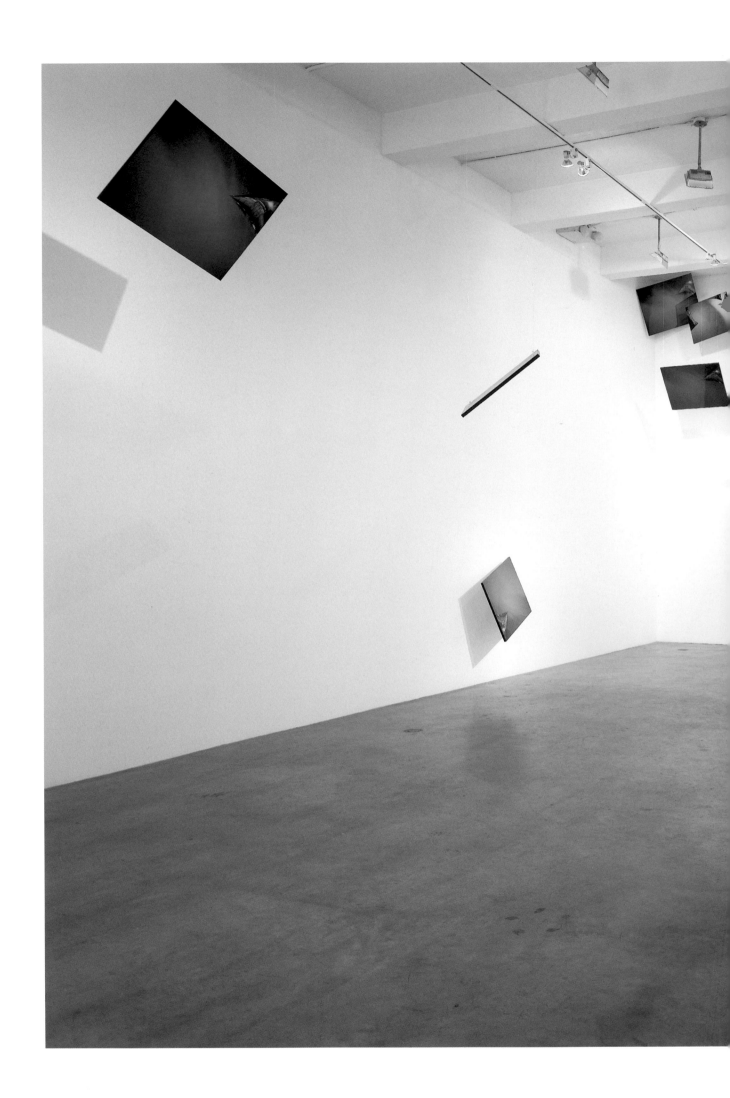

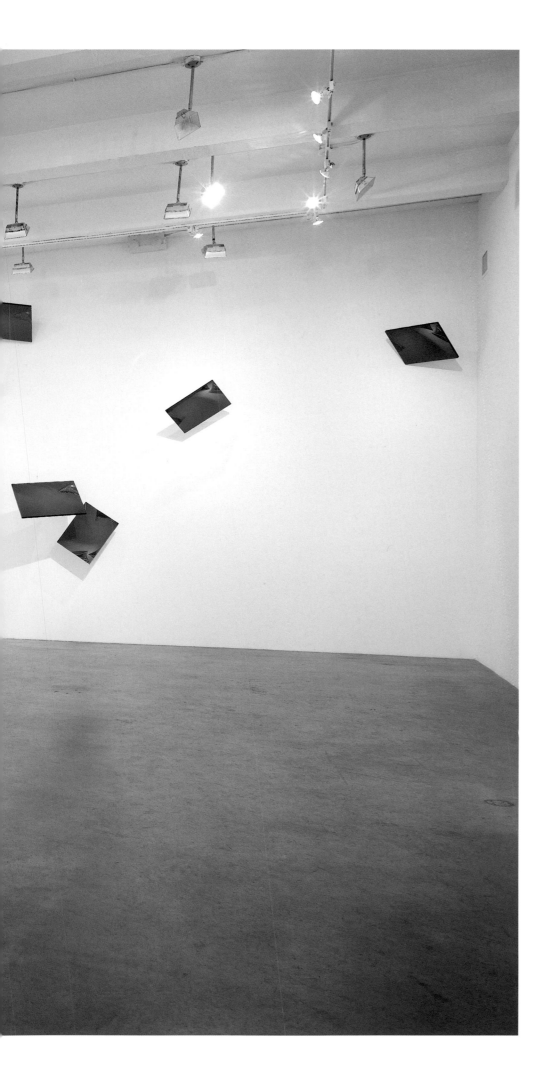

Installation View
More Pictures
Metro Pictures, New York, February 2000

Untitled (1950-51), 1987
cibachrome, 29³/⁸ x 39¹/⁴"

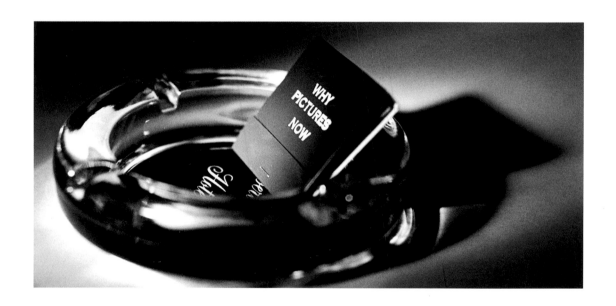

Why Pictures Now, 1981

black and white photograph, 3 x 6"

o.10081941

Acknowledgements

This book, having come into being between March and May of this year, it is very simple to thank those directly involved: Dorothée Walliser for her expertise, good graces, and sensitivity to bringing this book together, Prosper Assouline for originating the support, and Philippe Segalot for being the catalyst for the project.

I would like to thank Jeff Gauntt who has always handled my work in the right way at Metro Pictures, along with Janelle Reiring, Helene Winer, Tom Heman, Tony Huang, and Todd Hutcheson. Monika Sziladi working with me was constantly helpful in all aspects of decisions and organization. Here as elsewhere, Douglas Crimp and Johannes Meinhardt have brought forward and expanded the discussions involved in my work.

I hope my work itself acknowledges the dialogue set up by the work of others: writers, curators, gallerists, friends, fabricators, artists, and Andy Warhol.

Thanks Felix Nicholas Lawler Buchloh.